IMAGES
of America

PIQUA

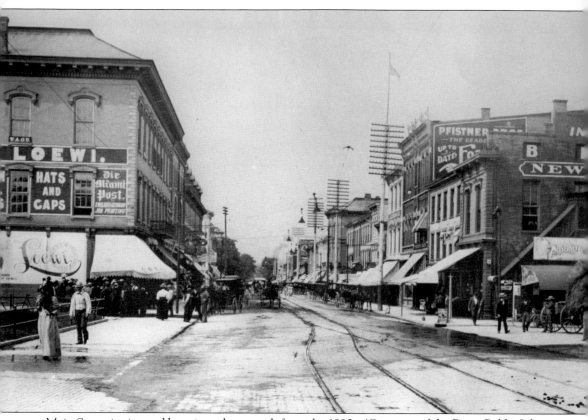

Main Street is pictured here in a photograph from the 1890s. (Courtesy of the Piqua Public Library Local History Department.)

IMAGES
of America
PIQUA

Heidi L. Nees and Michael M. Carver

ARCADIA
PUBLISHING

Published by Arcadia Publishing
Charleston, South Carolina

Printed in the United States of America

Library of Congress Control Number: 2013943426

For all general information, please contact Arcadia Publishing:
Telephone 843-853-2070
Fax 843-853-0044
E-mail sales@arcadiapublishing.com
For customer service and orders:
Toll-Free 1-888-313-2665

Visit us on the Internet at www.arcadiapublishing.com

*To those who believe in Piqua as a community
and its past, present, and future.*

CONTENTS

ACKNOWLEDGMENTS

We humbly thank the staff at the Piqua Public Library, especially Jim Oda, Gary Meek, Sharon Watson, and Roger Hartley—the people of Piqua have an amazing resource and treasure in the local history department at the library. Many thanks also to Andy Hite, site manager of Johnston Farm & Indian Agency; Jim McMaken and Donn Craig at the Miami County YMCA; and Leesa Baker, executive director of the Piqua YWCA. We would also like to thank Mary Margaret Schley, our editor, who has provided us with much in the way of guidance and support.

Unless otherwise noted, all images are courtesy of the Piqua Public Library Local History Department.

INTRODUCTION

The history of Piqua, as is the case with so many communities, is intertwined with the river next to which it was founded—the Great Miami. The river offered sustenance to the area's first residents, mound builders who established settlements on the banks of the river more than 3,000 years ago. To those who arrived in later centuries, the river afforded Piqua's residents an avenue to prosperity by encouraging the construction of a canal in the mid-19th century that fueled commerce and development. Railroads and various manufacturing firms followed in the canal's wake, further bolstering the town's fortunes as it spread to assume the dimensions of a city. Piqua entered the 20th century with all the hallmarks of American progress: numerous and vibrant churches, secure banks, productive industrial and agricultural sectors, and a variety of active civic organizations.

Piqua's name is rooted in legend, and its past is rich in Ohio history. The former comes from the anecdote shared by George C. Johnston, who first arrived in Piqua in late 1817 with a license to trade with the local Shawnee; he earned their business as well as their trust. As an adopted member of the Shawnee, Johnston became fluent in their language and well acquainted with their lore. One story revealed how the community acquired its name. According to the tale, after the Shawnee cremated a Native American enemy captive only to witness the incinerated prisoner rise from the pyre to reassume his previous form, the bewildered Shawnee called out, "*Otatha-he-wagh-piqua*." (He has come out of the ashes.) Johnston became a repository of such local myths and legends, as well as a critical figure in the area's history, standing alongside such prominent individuals in American and Ohio history as George Rogers Clark, Anthony Wayne, Tecumseh, and William Henry Harrison.

The Piqua area's first residents from the Adena and Hopewell peoples constructed elaborate mounds on the outskirts of what became Piqua centuries before the arrival of the Miami in the 1600s. Trade with the Miami population, led by Chief Old Britain, attracted approximately 50 colonial traders to the area in the mid-1700s to establish a permanent trading post and fort called Pickawillany. French troops and their Native American allies destroyed Pickawillany in 1752 in a clash cited by many scholars as the first battle of the French and Indian War, and the area remained hotly contested by the British and the French for the duration of the conflict. The chaos of the American Revolution in the Ohio Valley encouraged a wave of resettling by displaced members of the Shawnee and the establishment of two villages, Upper and Lower Piqua, in the 1780s.

Shortly before the outbreak of the War of 1812, Col. John Johnston relocated from Fort Wayne, Indiana, where he supervised two Indian agencies, to serve as the local Indian agent at Fort Piqua. His position entailed monitoring the activities of 6,000–10,000 Native Americans living on the land surrounding Fort Piqua and ensuring they stayed out of the conflict. During the war, the federal government arranged a treaty with the Indians, guaranteeing their neutrality in exchange for food and sanctuary. American troops used Fort Piqua as a supply base and occasional command post during the war.

By the end of the conflict, the area's population had expanded to the point that the Ohio legislature voted in 1822 that Piqua, with its nearly 300 residents, be incorporated as a town. Piqua reincorporated 12 years later and elected John Johnston, the well-regarded Indian agent, as its first mayor. The population increased more than tenfold by 1860, reaching 4,616 living within the city limits, due in large part to a steady stream of German immigrants from the 1830s until the outbreak of the Civil War in 1861.

Piqua enjoyed the benefits of mid-19th-century America's modernizing economy and advances in transportation with the construction of the Miami and Erie Canal in the 1830s. The burgeoning town served as the midway point between the cities of Toledo and Cincinnati and as an important stopping point for flatboats traveling as far south as New Orleans, until the canal ceased to function in 1912. The expansion of railroads provided Piqua with yet another source of affluence and distinction, beginning in 1856 when the Dayton & Michigan Railroad reached Piqua. Subsequent lines to stretch through the city included the Columbus, Piqua & Indiana Railroad in 1858. Technological innovation continued to transform Piqua into a modern urban center, replete with telegraph lines in 1850, telephones in 1880, and electric lights in 1884. Piqua could boast 79 reported manufacturers in 1906, producing a diverse array of products that included furniture, farm tools, paper, stoves and ranges, and underwear.

Civic-mindedness galvanized members of the community to come together in organizations such as the YMCA in 1877 and the Knights of Columbus in 1906. The women of Piqua, in particular, pooled their time and energies into a number of active clubs. Piqua's earliest club for women was the Fortnightly Club, established in 1889 as a reading group that assembled every two weeks to discuss literature. The Piqua chapter of the National Society of the Daughters of the American Revolution was another early association for women. Organized in 1896, the Piqua Daughters busied themselves with fundraising efforts to commemorate local historic events through the placement of markers and gravestones at locations such as John Johnston's old Indian Agency House and Pickawillany, the site of the last major battle of the French and Indian War.

The sense of community demonstrated by such organizations was put to the ultimate test during Piqua's most calamitous event, the flood of March 1913. After three days of torrential rain beginning during Easter weekend, the levee holding back the rising waters of the Great Miami in East Piqua gave way, carrying with it automobiles, houses, and a number of residents. Numerous lives were lost in this disastrous event, but valor mingled with tragedy, as the flood set the stage for numerous examples of personal bravery, with neighbors risking or losing their lives in attempts to save the lives of others.

Piqua recuperated from the deluge and continued to expand in the 1910s and 1920s. The flood awakened a renewed sense of community service and promoted the creation of a local chapter of the Rotary in 1915. By 1929, Piqua's population stood at 19,000, living in three sections of the city: Shawnee, Rossville, and Piqua proper. Main Street featured a number of vendors, including department stores. Three downtown theaters offered an array of live and cinematic entertainment, and each summer brought with it performances courtesy of Ringling Bros., Barnum and Bailey, and other circuses.

The pictorial record that follows is a reminder of Piqua's rich and captivating history and a tribute to just a handful of the men and women who proved instrumental in laying the foundation for the city along the banks of the Great Miami River and fulfilling the city's motto: "Where vision becomes reality." In the following pages, the authors have aimed to share images of Piqua's past, but even more so, they have attempted to look at how Piqua has celebrated, commemorated, and performed both its history and identity. These images reflect who the people of Piqua are as a community and how they present that community to each other and the world beyond.

One

PIQUA'S HISTORICAL BACKGROUND

One may consider Piqua's history to be a microcosm of America's history. At every major phase of the development of the United States, Piqua experienced similar forces. The area surrounding Piqua served as the backdrop to a number of dramatic events in America's colonial period, including the French and Indian and Revolutionary Wars. As America developed into a commercial power in the period before the Civil War, so did Piqua, expanding as canals and railroads stretched across Ohio. Multiple industries set up shop in the prosperous city in the late 1800s and early 1900s. The horrendous flood of 1913 took lives and destroyed property but could not damper the sense of community that would allow Piqua to rebuild and move forward through the 20th century. As young men fought through two world wars, Piqua watched many of its own leave for the front lines. In the postwar period, as the nation experienced financial and technological resurgence, Piqua followed suit, establishing itself as "the atomic city." As the nation sought to preserve its history in the latter half of the 20th century and into the 21st, Piqua did the same, looking to preserve its historic and cultural landmarks, remembering the past while forging ahead into the future.

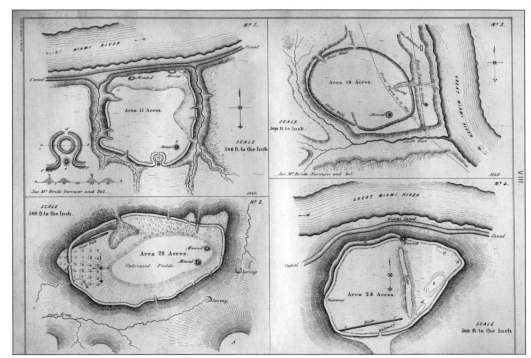

This is an 1848 illustration of the locations of four mounds constructed by indigenous mound builders in the Piqua area, most likely for the purposes of signal stations. Though lost over the centuries to agricultural and industrial development, the historic Johnston Farm site features surviving examples of such mounds.

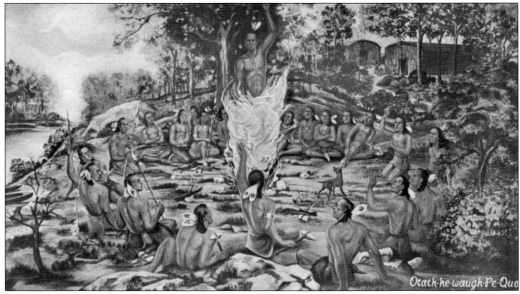

Here is the legend that inspired a community's name: "*Otatha-he-wagh-piqua*" (He has come out of the ashes), the fearful cry of the Shawnee warriors beholding a recently cremated enemy rising up from the vestiges of the fire. Some debate continues as to whether this apocryphal event is the source of Piqua's name, but the long-standing effect of local Indian culture on Piqua's history is undisputed.

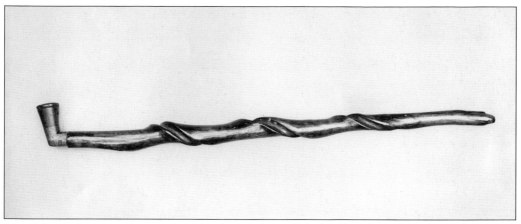

John Johnston's peace pipe, one he shared regularly with the leaders of the Shawnee and Wyandot tribes, is pictured here. His position as Indian agent required him to keep close contact with these nations. Johnston maintained views on Native Americans far more progressive relative to most white Americans of his era, making great efforts to learn Indian languages and cultures. He was an early advocate for federal protection of Indian lands and peaceful coexistence between native and non-native populations.

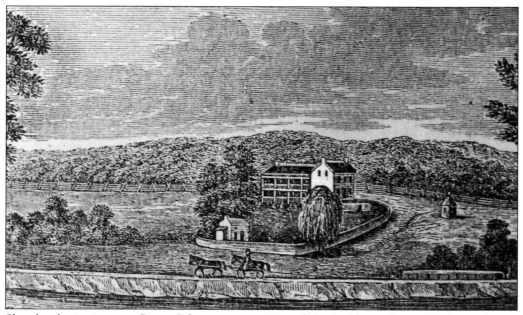

Shortly after arriving in Piqua, Johnston commissioned the building of a suitable house for his wife, Rachel, and their growing family. The couple had 15 children in all, with 14 living to see adulthood. Construction on the brick farmhouse concluded in 1815, and the Johnston family moved in that summer. Later structures included a large barn and a springhouse, which can be seen in this mid-18th-century engraving just behind the mule team pulling a canal boat.

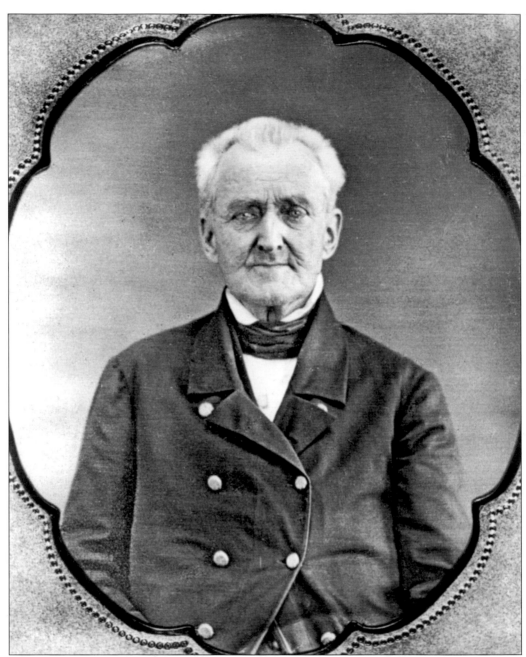

John Johnston, shown here in his later years, remained a prominent figure in Ohio up until his death in Washington, DC, on the eve of the Civil War in 1861. He acted as a guiding force during the early years of Ohio's development after it gained statehood. In addition to a three-decade-long career as one of the country's most competent Indian agents, Johnston served as a canal commissioner and assisted in the formation of Kenyon College and Miami University. His lifelong interest in Native American cultures and firsthand experiences with various tribes made him a unique source of knowledge and insight that would have been of great value to federal officials had they bothered to seek his counsel. Johnston left Piqua following the death of his wife in 1840 to take up residence in Cincinnati and later Dayton.

Piqua benefitted enormously from the construction of canals during the early decades of the 1800s. Workers began constructing the Miami Canal in the mid-1820s, and in 10 years' time, the canal reached the boundaries of Piqua. It formally opened in 1837 with great fanfare and a celebration at which future president Gen. William Henry Harrison was the guest of honor.

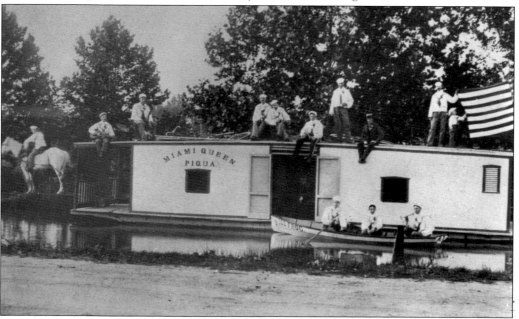

Trade along Ohio's canals dwindled after 1850, a victim of the growing prevalence of railroads. Piqua's most prominent business and political leaders fought tenaciously to keep the Miami and Erie Canals open, with some success, although the area of operation shrank to local and regional usage. During the late 1800s and early 1900s, the canals carried pleasure boats, such as the *Miami Queen*, featuring picnics and bands to entertain passengers.

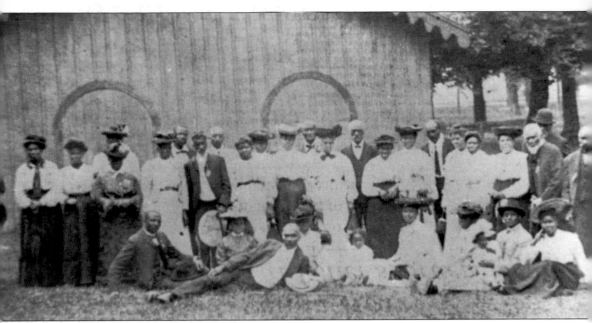

The nearly 400 slaves belonging to John Randolph, a prominent politician and plantation owner from Roanoke, Virginia, gained their freedom in the 1840s following his death and a protracted court battle. After undertaking an exodus from Virginia in search of a new life and new opportunity, many made their way north from Cincinnati to Piqua, where they established households on land purchased in Rossville, located north of the Miami River, and two other communities near West Milton and Troy. Some of the original members of the Randolph Slaves and their descendants are seen in this 1890s photograph. The Jackson Cemetery in Rossville is the area's oldest African American burial ground. It is the resting place of many of Randolph's manumitted slaves.

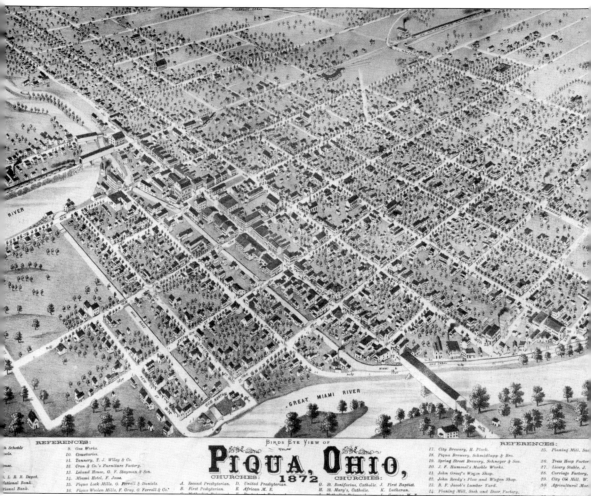

This bird's-eye view of Piqua in 1872 shows just how much expansion the community experienced throughout the 19th century, thanks in large part to the commerce afforded by nearby canals and later railroads. By this date, Piqua had a public school system, two national banks, and a public gasworks. A dozen different churches, three of them Presbyterian and two Catholic, attended to the spiritual needs of area residents. The community's population stood at approximately 6,000. Local industries included three breweries, two wagon shops, a lumberyard, and factories producing carriages, doors, and dress hoops. Underwear producers had yet to establish a presence in Piqua but would do so before the close of the century. This map does not include the over 50 saloons and unknown number of gambling dens also present in the community, although their presence and influence did not go unnoticed by temperance groups such as the Women's Christian Temperance Union.

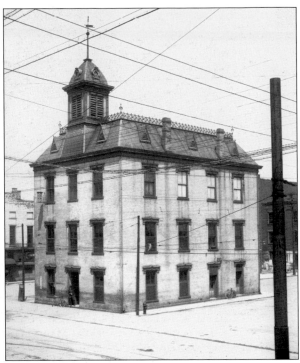

Piqua's town hall is pictured as it appeared on Main Street in the early 1900s. In March 1842, the city council decided to construct the building, which initially was planned as two stories rather than three. J.R. Hillard was contracted for the building project at a cost of $3,200. He completed the job in late 1844. After more than 80 years of use, the city council relocated from the brick building to the site of the Central Fire Station on Water Street in the late 1920s. The old building was torn down shortly thereafter.

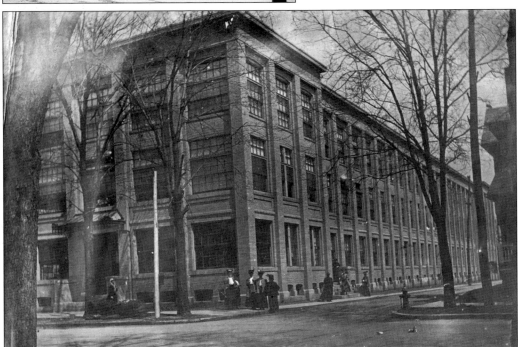

Piqua bore its nickname, "the Underwear Capital of the World," with pride. This image of the Atlas Underwear Company in the early 1900s shows the second plant the company constructed. Atlas began operation at the start of the 20th century and continued to be a critical source of jobs for almost a century. In the 1980s and 1990s, citizens celebrated their city's unique manufacturing heritage with the Underwear Festival.

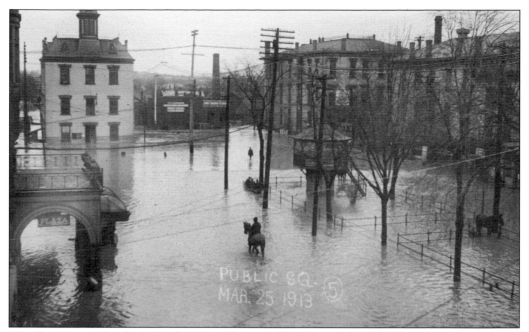

The devastating flood of 1913 left surreal images like this in its wake. The Great Miami River flooded regularly throughout the 1800s, but the relatively sparse population kept the loss of life and property low. This changed by late March 1913, when excessive rainfall over several days caused the river to overspill its banks and pour into the streets of Piqua.

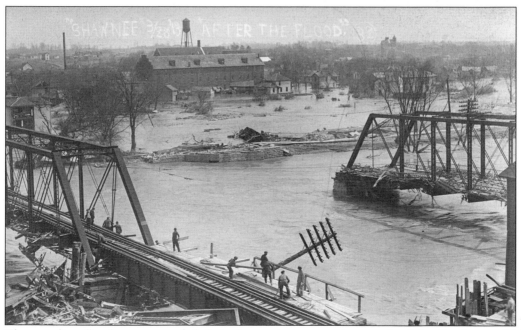

The receding floodwaters revealed their destructive power. As a result of the flood, over 30 people died, most of them children and older residents. After the flood, the Miami Conservancy Company built a series of retarding basins located at Lockington, Englewood, and Taylorsville. Other precautions against future floods included strengthening and widening existing levees.

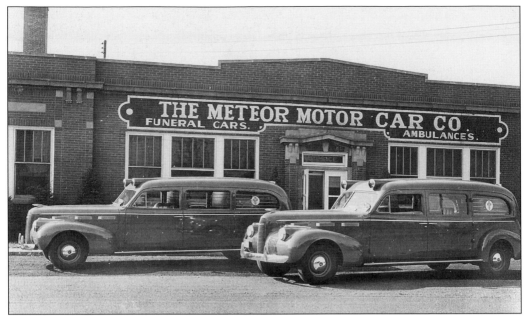

The Meteor Motor Car Company relocated from Shelbyville, Indiana, to Piqua in 1913. A rented factory started out assembling two models of passenger cars before Maurice Scott Wolfe, the company's founder, oversaw a changeover to producing ambulances and hearses exclusively. The business took off, and Meteor built a larger facility to meet its needs in 1925. Meteor produced these ambulances in the late 1940s.

The Piqua Hosiery Company began production in Piqua in 1886, the first of ultimately 10 manufacturers of undergarments located in the city, including the Atlas Underwear Company. By the 1930s, when this photograph was taken, Piqua was rightly known as "the Underwear Capital of the World."

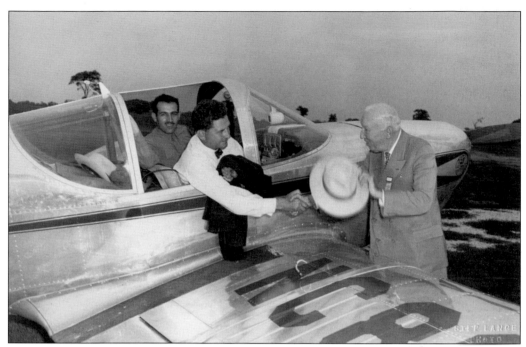

One of the outstanding servicemen from Piqua, Don Gentile demonstrated a marked interest in aviation from an early age. He graduated from Piqua High School in 1941 and enlisted in the Canadian RAF shortly thereafter. He transferred to the US Army Air Force in September 1942 and accrued a wartime record of 26 enemy aircraft destroyed. In this 1946 photograph, Gentile is seen after landing the plane that carried Ohio governor Frank Lausche to Piqua's sesquicentennial festivities.

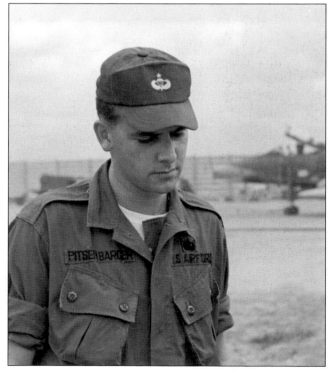

William H. Pitsenbarger displayed exceptional courage and valor serving as a pararescueman for the Air Force in the early years of the Vietnam War. Pitsenbarger joined the service shortly after graduating from Piqua High School in 1961. Following training in Texas, he shipped out to Vietnam and took part in close to 300 rescue missions. On the last one, he selflessly protected and cared for a group of wounded soldiers. He received the Congressional Medal of Honor posthumously in 2000.

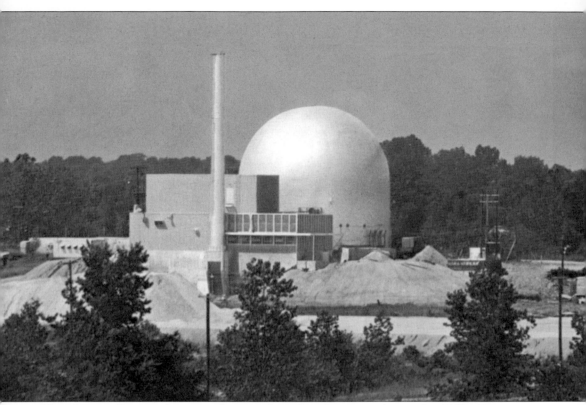

The municipally-owned atomic plant ran for only a short time during the 1960s. Piqua was one of the first communities in the United States to utilize nuclear power after World War II. The prospect of the new facility initially filled area residents with great enthusiasm. Piqua garnered the new nickname "the Atomic City." Construction began in the late 1950s, and the plant started to produce energy for Piqua in 1963. Operational problems resulted in the plant closing for repairs in 1966. It never reopened.

Two

FESTIVALS, PARADES, AND COMMEMORATIONS

In every community, members look for ways to celebrate their identity and history. Over the years, Piqua has used cultural expressions such as festivals, parades, and commemorations to support its inception, histories, and notable citizens. Previous generations needed little prodding to assemble a colorful caravan of floats, animals, and local celebrities, ready to promenade down Main Street in parade formation. Whether it was a holiday, a good harvest, or a returning war hero, the people of Piqua lined the streets to cheer and wave. Piqua continues its tradition of parades as well as festivals, the Heritage Festival being one of the most popular annual events for the community.

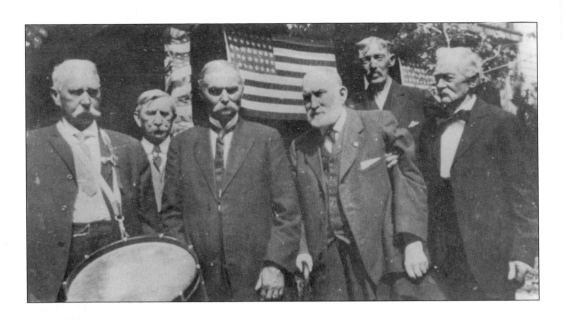

The older gentlemen in this pair of images answered the call by serving in the Union Army during the Civil War, most likely as members of the 110th Regiment in the Ohio Volunteer Infantry. Most men who fought for the Union did so after enlisting rather than waiting to be drafted. Veterans from the North and South took part in reunions for the remainder of their lives, with Union veterans organizing the Grand Army of the Republic (GAR). These GAR reunion photographs were taken during the early 1900s. The image below features members of the GAR Drum Corps.

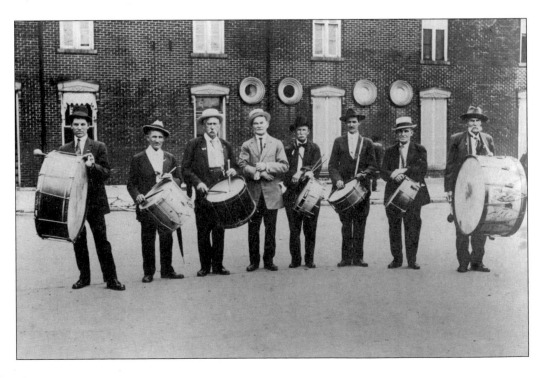

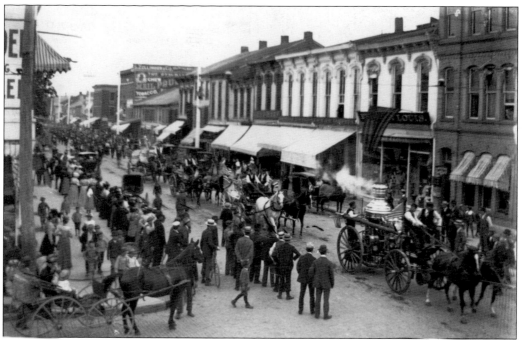

The first-known photograph of a parade down Main Street, taken around 1900, quite prominently features a contingent of the Piqua Fire Brigade, including a horse-drawn, steam-powered fire wagon. Starting in the late 1830s, volunteer firemen kept vigil over Piqua as separate companies until a consolidation in the early 1880s gave the city control over a single department. The cowboys and buffalo statue topping a wagon in the photograph below are part of a show traveling from the train depot to the performing grounds. Circus parades such as this acted as tantalizing previews of the shows and attractions awaiting those who attended the events.

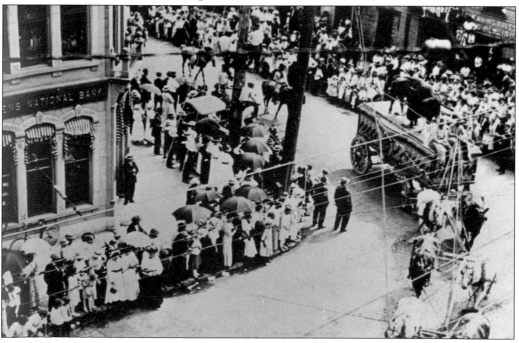

Piqua's Chautauqua was the city's longest continuous community festival. The Piqua Community Chautauqua Association hosted its first festival in Fountain Park over 11 days during August 1912. The festival grew in prestige over the years as it attracted speakers such as evangelist Billy Sunday and famed writer and traveler Lowell Thomas. These 1912 attendees are posed in front of one of the many temporary structures erected during the festival.

Piqua city leaders decided the popularity of the Chautauqua Festival demanded a permanent structure be built after World War I. The 5,000-seat Hance Pavilion opened in 1921, the year this photograph of Chautauqua attendees was taken. During the 1930s, the Chautauqua Festival attendance dropped off, a victim of new pastimes such as radio and movies, as well as advances in transportation.

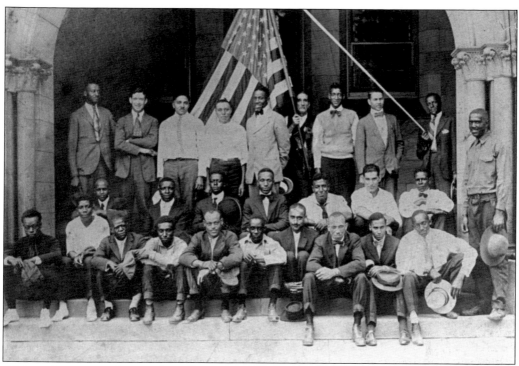

African American selectees from Piqua are pictured above in August 1918. Before World War I ended the following November, a number of Piqua residents saw action in Europe as members of the Ohio National Guard in the 37th Infantry Regiment. The 37th took part in some of the most hellacious fighting, including the Allied counteroffensive in the summer of 1918. Below, members of the Piqua High School band are preparing to honor soldiers returning from France in late 1918. Seventeen Piquads died while serving in World War I.

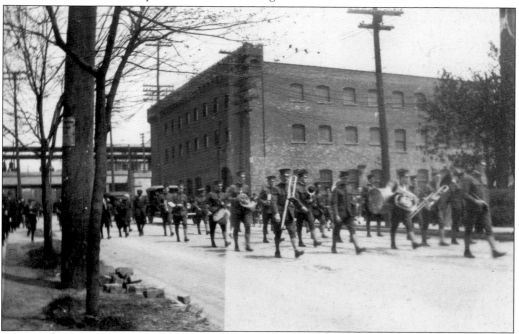

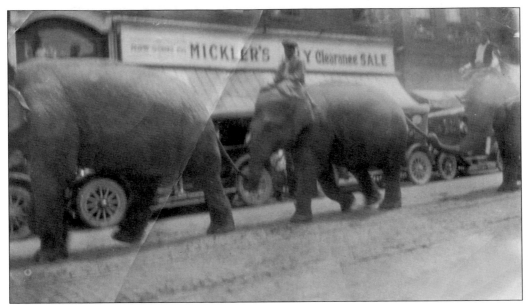

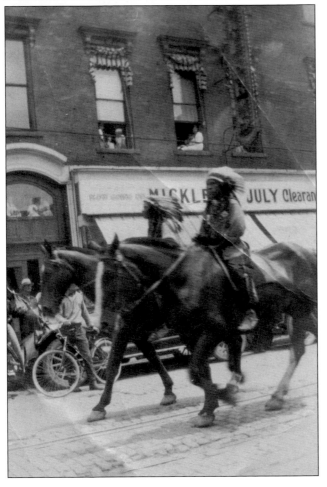

This circus parade from the 1920s, which featured elephants and Indian riders, was one of a number of such colorful processions to march from the train depot, down Piqua's Main Street, to a show lot made available by the Meteor Motor Company. The number of railroad lines passing through Piqua, including the Pennsylvania Railroad, made it an ideal location for staging a circus during the summer. In July 1928, two trains from the John Robinson Circus traveled from Columbus to Piqua to give two performances featuring bears, camels, leopards, lions, and tigers. Each show opened with an extravagant spectacle called "King Solomon and The Queen of Sheba." The Higgins drugstore sold tickets. A second circus, the 101 Real West and Great Far East Circus, came to Piqua from Lima in early September to perform at the Meteor circus grounds.

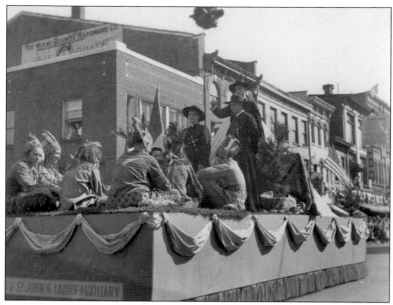

These two floats sponsored by local organizations took part in the September 23, 1938, sesquicentennial grand parade commemorating the organization of the Northwest Territory. A series of floats representing critical junctures in Piqua's development traveled down Main Street in chronological order. The first float carried reenactors of the Miami and Shawnee tribes residing in the region before the arrival of the first white inhabitants. The second float (above) showed French missionaries bringing their message to the indigenous population of the Miami Valley in the 1600s. Many depictions of the Indian heritage of Piqua, like those seen here, depend exclusively on non-native representations of indigenous cultures. Another float (below) featured a reconstruction of the canal boat *Clarion*, commemorating the canals that proved instrumental in the early history of Ohio. Such parades continued to be common in Piqua in the 1930s, 1940s, and 1950s. The Elks held their annual parade to commemorate Flag Day and, at the suggestion of member and local businessman Joe Thoma Jr., the Kiwanis sponsored a Halloween parade every year starting in 1954.

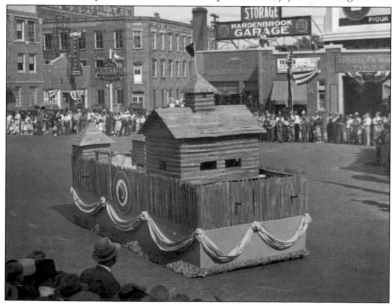

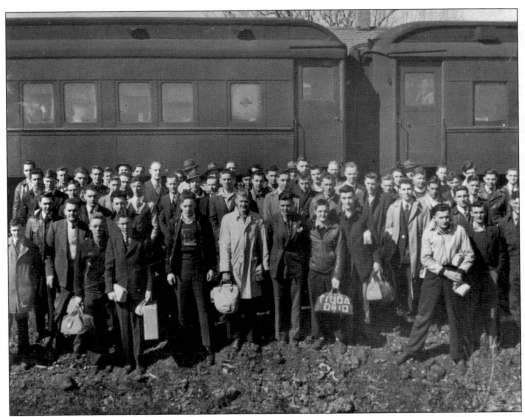

When war descended upon the United States in late 1941, the residents of Piqua, like so many across the nation, made the conflict a community affair. This started first and foremost with young men putting aside the comfort and safety of home to restore peace and stability. These young men are among the nearly 3,000 from northern Miami County who joined the armed forces.

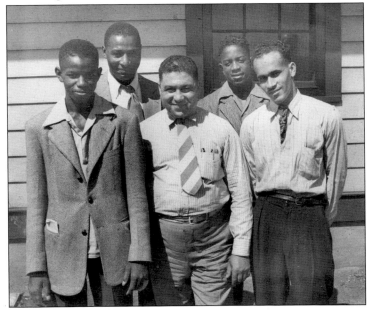

These young African American enlistees from Piqua went off to serve in a military still segregated along racial lines. Piqua's African American population has a long tradition of military service, sending soldiers to serve in wartime dating back to the Civil War. Pictured from left to right are Charles Taylor, Ken Wells, Dutch Davis, Jesse Olden, and Bob Smith.

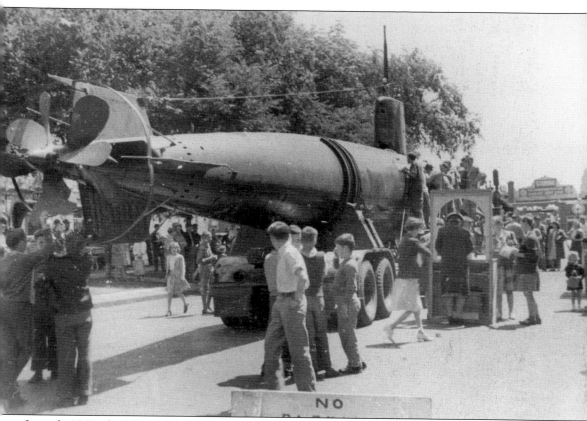

NO

In early 1942, the US Navy sent a Japanese "midget" submarine on a tour of the United States as part of a larger effort to raise morale and money for war bonds. Piqua was selected as one of the tour stops. This sub was part of the Japanese naval task force that struck Pearl Harbor on December 7, 1941. Its two-man crew was forced to abandon their craft after an encounter with an American destroyer. It later washed up on the beaches of Oahu.

Don Gentile's impressive wartime record serving as a fighter pilot resulted in his receiving the British Distinguished Flying Cross in 1942 and the Distinguished Service Cross in 1944 from General Eisenhower, who dubbed Gentile "the one-man air force." In recognition of Gentile's accomplishments, Piqua officials and residents held Don Gentile Day on May 25, 1944, to honor the young pilot on leave at the time. Celebrations included a parade, bond rally, and speeches. Gentile survived 182 combat missions and destroyed 26 German planes, only to lose his life in January 1951 when the T-33 jet trainer he was flying in Maryland crashed 25 minutes after takeoff. He was 30 years old. Gentile received a posthumous promotion to major. The City of Piqua dedicated a statue to its hero on the public square in the summer of 1986.

Piqua observed another sesquicentennial in 1946, this time in honor of the community's 150-year anniversary. Part of the advertising campaign for this commemoration included this group of local girls representing a city enjoying postwar stability. In 1946, Piqua's expanding population stood at 20,000 residents attending 26 churches, laboring in 30 assorted local industries, and supporting an excellent school system.

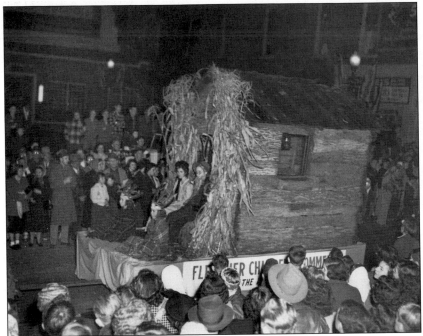

Festivals and parades to celebrate autumn harvests in Piqua began in the mid-1800s and continued into the following century. These images from the 1949 Corn Festival Parade show how the community used parades to honor both distant and recent historic events. The chamber of commerce sponsored the above float, in which the youngsters decked out in period attire and seated in front of a rustic log cabin are a clear reference to Piqua's pioneer past. Below is a military Jeep trailed by a row of veterans representing the various branches of the US Armed Forces, just four years from their wartime experiences in Europe and the Pacific.

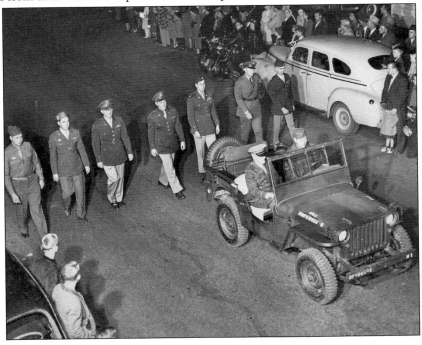

Communities large and small across the country celebrated the nation's bicentennial in the summer of 1976 with a wide array of festivities. Piqua was no exception to this and commemorated its colonial past by constructing an elaborate replica of Fort Pickawillany on the public square. Visitors to the simulated fort could take a tour and learn of its place in the history of Piqua, courtesy of tour guides dressed in 18th-century garb.

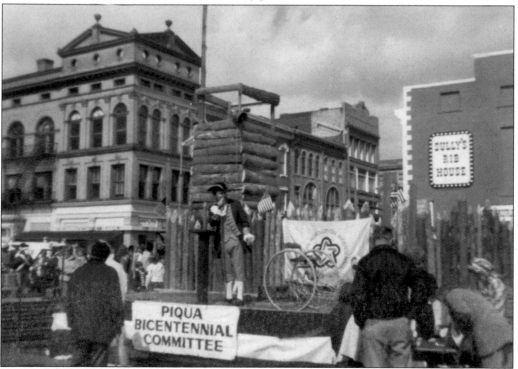

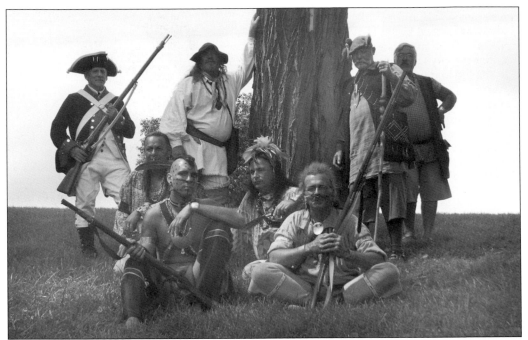

Piqua's Heritage Festival is the largest continuing annual community celebration of the area's past. It unfolds every Labor Day weekend on the grounds of the historic Johnston Farm and Indian Agency. Reenactors, such as those above, assist visitors in understanding the impact of Native Americans, white trappers, and soldiers on the Ohio frontier in the 18th and early 19th centuries. The festival also affords attendees the opportunity to sample a wide array of local cuisine, prepared and sold by community clubs and organizations. Annual favorites include tenderloin sandwiches from the YMCA Judo team, St. Paul's Church's chicken and noodles, and as pictured below, the Rotary Club's corn on the cob. (Both, courtesy of Sharon Watson.)

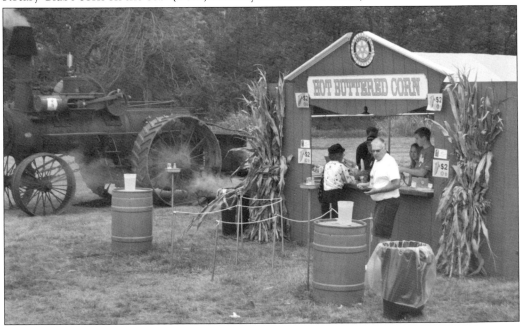

Piqua's memorable and short-lived Underwear Festival began in 1988. A group of 15 local merchants decided to honor the city's manufacturing past in a fun and unique way by organizing an annual celebration that encouraged residents to take to the streets wearing the union suits once produced in the thousands by companies such as the Atlas Underwear Company and Superior Underwear. Piqua held its last Underwear Festival in 1998.

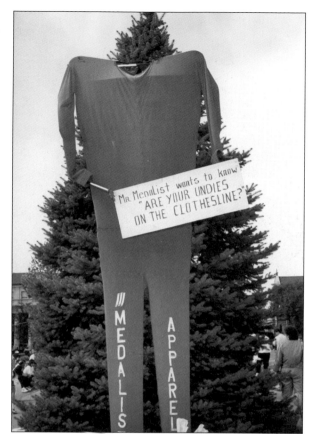

The Underwear Festival included a number of events to entertain attendees, such as a race (the Drop-Seat Trot), a fashion show showcasing vintage underwear styles, a talent show, and a go-cart race (the Undy 500). Entertainers such as George Burns, Whoopi Goldberg, and Lucille Ball as well as former presidents George H.W. Bush and Bill Clinton donated their undergarments for the celebrity underwear auction pictured below.

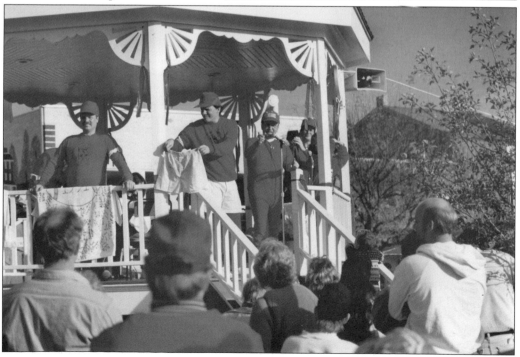

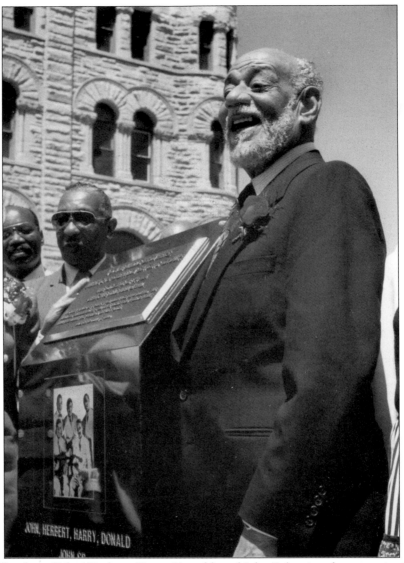

JOHN, HERBERT, HARRY, DONALD
JOHN SR.

The Mills Brothers (John, Herbert, Harry, Donald, and John Sr.) enjoyed a meteoric rise to fame in the late 1920s and early 1930s, starting when Duke Ellington advised his manager to sign the group in 1929 after hearing their distinctive harmonizing. Tragedy struck the group in 1936 when John Jr. died of pneumonia. His father, John Sr., took his place, and the group moved forward, recording hit songs like "Paper Doll" and "Lazy River" and hosting a network radio show—the first African Americans to do so. Throughout their remarkable careers, the Mills Brothers retained ties to their native city. The group performed at Schine's Piqua Theatre in 1932 and continued to return to visit friends and give concerts over the years. Piqua dedicated a downtown monument to the Mills Brothers in June 1990. Don Mills, the last surviving member of the group, attended the dedication in the public square (pictured). He returned in 1998 to give a concert with his son John at Piqua High School before his death the following year at the age of 84.

Three

THEATER AND PERFORMANCE

Performance is but one way in which a community reflects itself to the outside world. Piqua has long had a tradition of supporting live performance, whether it be treading the boards in plays or playing in bands or orchestras. Such outlets were particularly popular before the advent of records, radios, movies, and television. May's Opera House, built in the early 1900s, served as a venue for such renowned performers as Harry Houdini. It also provided a location for area performers to showcase their burgeoning talents, as was the case for the Mills Brothers. Local theaters later showed motion pictures from their infancy as they transitioned from silent to sound. The people of Piqua found numerous ways to showcase their musical talents, including church and school choirs and community and club bands. What follows in this chapter is a small selection of the numerous performance talents to emerge from Piqua.

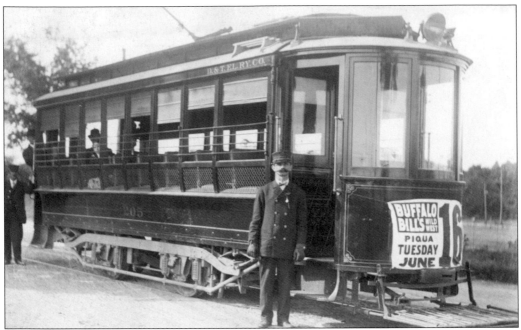

This streetcar is advertising the impending arrival of Buffalo Bill's Wild West in the early 1900s. Buffalo Bill Cody first performed in Piqua in March 1877 at Conover's Opera House, a performance that included the famous recreation of his scalping of Chief Yellow Knife at the Battle of Indian Creek in July 1876. A supposed act of retaliation for the massacre at Little Big Horn, Cody grew weary of performing *The Red Hand* or *Buffalo Bill's First Scalp for Custer* in his later years.

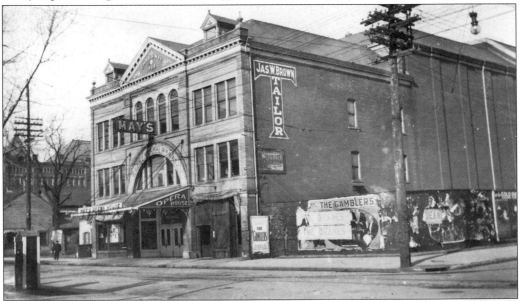

Piqua's largest theater, May's Opera House, stood on the east side of Wayne Street between Market and Water Streets. Charles May built the grand structure in 1903 as a road show house for traveling performance troupes, but the theater shifted to screening movies in 1917 as live entertainment waned in popularity. May's continued to feature vaudeville on Saturdays, with local groups such as the Mills Brothers performing before film showings.

Though smaller and less ornate than May's, the 200-seat Favorite Theatre on the southeast corner of High and Main Streets, seen here in 1912, did brisk business at a time when most Americans attended the movies on a weekly basis. Other theaters, including the 400-seat Bijou, built in 1903 on West Ash Street, catered to the needs of Piqua's movie-enthused population. The photograph at right shows the theater's facade, and below is the Favorite's rather modest interior.

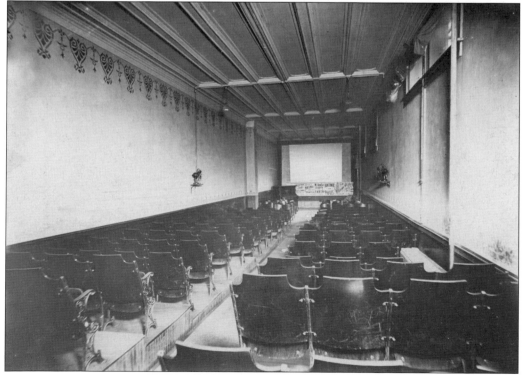

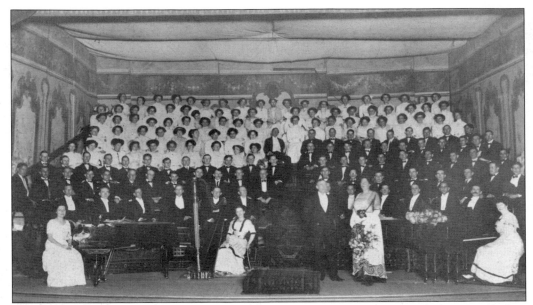

The residents of Piqua have a long history of participating in local musical groups, including orchestras, bands, and choirs. This photograph from the early 1900s shows a mass choir consisting of multiple choirs brought together for a special performance at May's Opera House. While May's attracted top talent, such as Harry Houdini and John Phillip Sousa, it also provided a venue for gifted musical performers from the area.

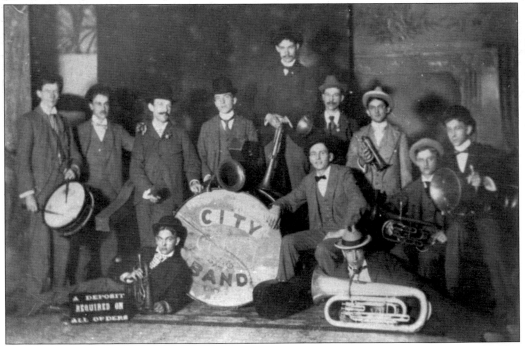

Posing around 1915, this casual grouping of performers from the City Band speaks to the group's less formal approach to performance compared to some of the other area bands. With its emphasis on brass instruments, the City Band was ideal for performing summer concerts in Fountain Park and the public square.

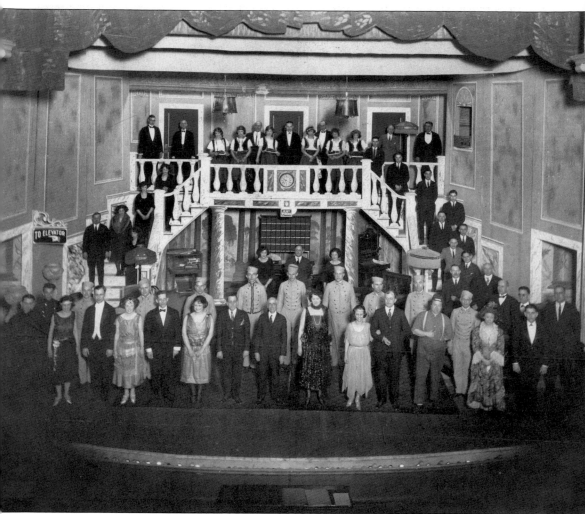

Officials of Rotary International were initially unsure if a city the size of Piqua could sustain a Rotary Club with the requisite membership or financial support before they granted a charter in 1915. Their concern proved unfounded; the local businessmen behind the Piqua Rotary Club put their business acumen to good use when raising funds for the group's various charitable interests. This included organizing dinners, auctions, dances, and live shows. During the 1920s, the Rotary Club put on a series of shows at May's Opera House called *Rotary's Rollicking Revue*. Rotarian Dudley King wrote the music and directed these annual shows. George Flesh provided the lyrics and dialogue. The casts of these revues, such as the one in this 1921 photograph, were drawn exclusively from local talent, who brought these original shows to life.

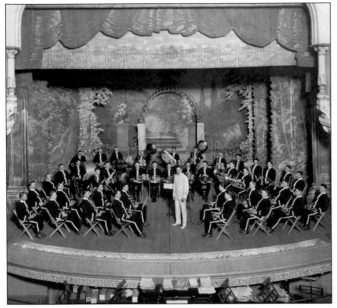

Live concerts at various venues have offered entertainment to Piquads since the 19th century. Outdoor venues have provided the residents of Piqua with numerous evenings of entertainment during the spring and summer. In the early 1900s, the city constructed a gazebo on the east end of the square specifically for Friday-evening summer concerts. A number of Piqua businesses sponsored groups like the Meteor Concert Band, shown here at May's Opera House in the early 1920s under the leadership of Dudley King. Meteor Motors' president Maurice Wolfe acted as the group's sponsor.

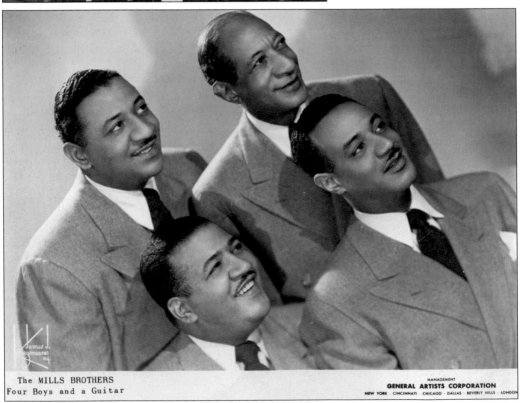

The MILLS BROTHERS
Four Boys and a Guitar

MANAGEMENT
GENERAL ARTISTS CORPORATION
NEW YORK · CINCINNATI · CHICAGO · DALLAS · BEVERLY HILLS · LONDON

Perhaps Piqua's most famous residents, the Mills Brothers (Harry, Herbert, Donald, and John Sr.) set the standard for crafting harmonious melodies during the golden age of American popular music. John Mills Sr. taught his four sons to harmonize at a young age. The boys gave impromptu recitals at their father's barbershop. Performances as Four Boys and a Guitar at May's Opera House led to appearances on Cincinnati's Station WLW, then Broadway and Hollywood.

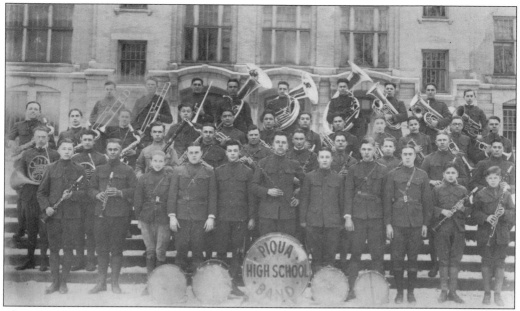

The Piqua Central High School marching band came together in late 1916 under the guidance of H.O. Ferguson. Leadership of the band passed to Phillip Gates the following year and remained his until 1944, during which time he invigorated Piqua High School's music department. Gates also found time to direct local church choirs and bands. Above is the band in 1921, only five years into its existence, but already having played an integral role at bond rallies during World War I and having assisted in welcoming the troops home in 1918. Their uniforms are reminiscent of those worn by American troops during the conflict, while those seen below in 1932 have considerably more flair.

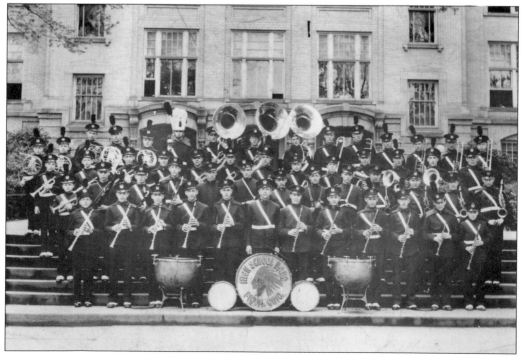

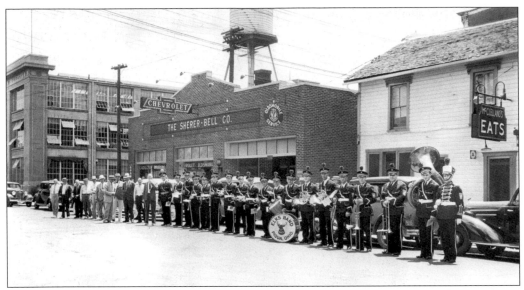

Like its Rotary Club counterpart, the Elks Club of Piqua, Lodge 523, sponsored musical acts during the 1900s to raise funds for local charities. The all-male Elks Club Band was founded in 1933 to perform a series of summer concerts in Fountain Park. The band won the Elks National Board Contest in 1935; this photograph of the group comes from the 1940s. In 1968, the Elks Club Band became the Piqua Civic Band and allowed women musicians to join.

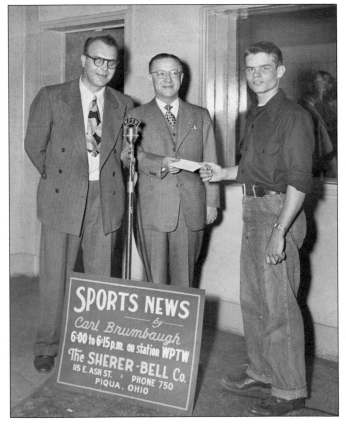

Piqua's WPTW radio station began broadcasting in 1947 with Richard E. Hunt (center) as its president and general manager. WPTW offered a diverse assortment of programs, including sports, news, radio dramas, and live musical performances. Carl Brumbaugh (left) hosted a sports show that awarded contest winner Cap Whitney (right), the owner of a Main Street sporting goods store, tickets to the Reds opening game in 1948 against the Pittsburgh Pirates. At the game, Whitney was reportedly seated in a box behind home plate next to popular entertainer Bing Crosby.

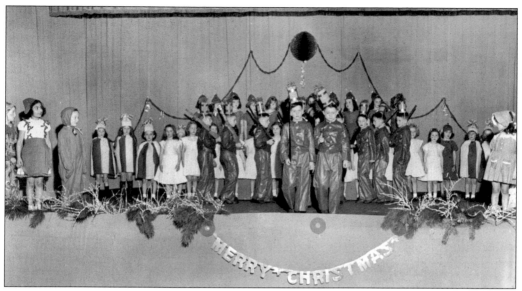

Piqua's many churches gave its youngest residents myriad chances to perform. The above photograph shows the cast members of St. Mary's Catholic Church's Christmas play in 1946. St. Mary's congregation, one of the oldest in Ohio, came together in 1843 in Piqua's first brick house of worship. The Park Avenue Baptist Church was built in the 1880s. Its children's choir is shown below in 1948.

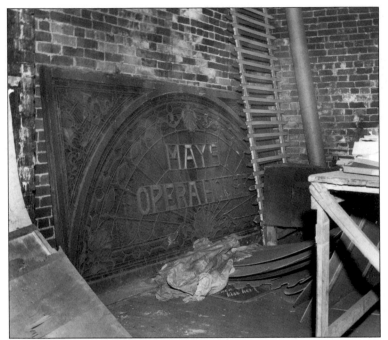

The owners of the three-story May's Opera House on Wayne Street remodeled the theater and stocked it with equipment for showing sound movies in 1930, just in time for Christmas. Later renamed the Miami Theatre, the venue fell into a state of disrepair by 1951, which prevented it from staying open. Workers razing the building in the late 1950s for a 44-car parking lot found the original May's sign from 1903, a relic of a bygone era.

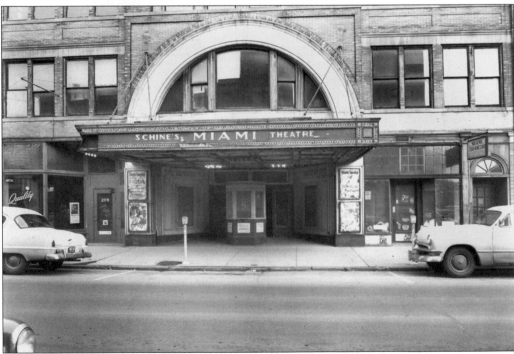

Schine's Miami Theatre on the corner of Main and Green Streets is shown here in the late 1950s after three decades of operation. It started as the Piqua Cinema in the late 1920s under the ownership of J.J. Collins and Thomas C. Fulton from Lancaster, Ohio. In the early 1930s, Schine's—a New York chain of independent theaters—assumed control of the Piqua Cinema and renamed it Schine's Piqua Theater. It would change hands once again in 1968, following a sale to Chakeres Inc., and would reemerge as the Piqua Theater.

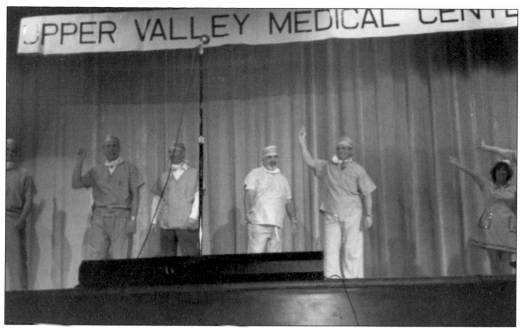

Area residents took to the stage in order to entertain and raise money on behalf of the Piqua Memorial Hospital in the annual Fractured Follies show during the 1980s and early 1990s. The scrubs and nurses' uniforms on full view in the above photograph from 1988 reference the intended recipient of the funds. Performers in Piqua also trod the boards as members of the Piqua Players, a community theater group organized in 1950. The photograph below shows the group in 1975 performing *Dirty Work at the Crossroads*. From left to right are Ann Borfels, Denise Zimbria, Pat Best, Lee Lawrence, Susan Parker, Jim Oda, and Jerry McAfee.

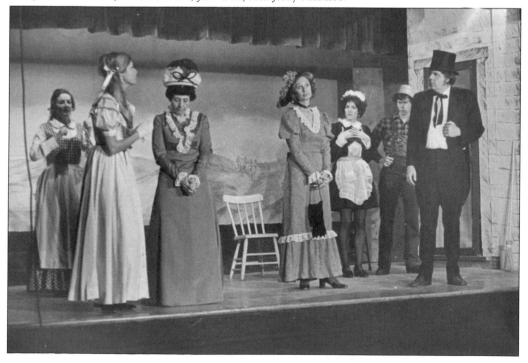

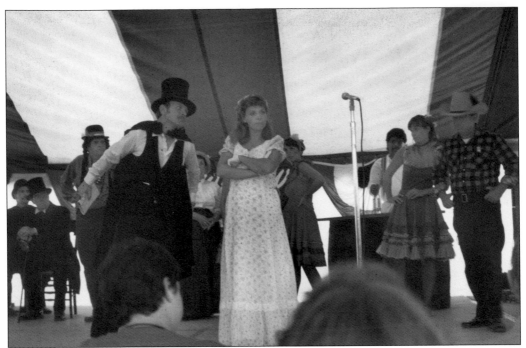

In addition to the food and reenactments offered at the annual Heritage Festival, the Piqua Players performed humorous melodramas, such as the one pictured above, at previous festivals. Other performances included a Wild West show, in which performers recreated shooting demonstrations by Annie Oakley and the theatrics of Buffalo Bill Cody, as seen below. The real Cody came to Piqua on more than one occasion with his troupe of performers in the late 1800s. (Above, courtesy of the Piqua Public Library Local History Department; below, courtesy of Sharon Watson.)

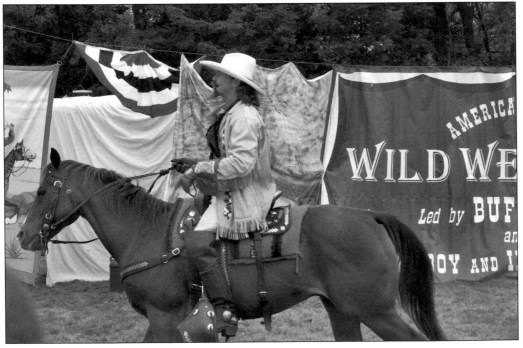

Four

SHOPPING AND DINING

Piqua has always been a hub for commerce, even during the colonial period when it served as a nexus for trade between the Miami Indians and English colonists. Canals and railroads cemented Piqua's status as a place with a strong business community. As the community grew and prospered, more businesses appeared to serve the needs of Piqua's residents as grocery stores, breweries, barbershops, saloons, and restaurants sprung up. Such places provided goods and services, and also provided places where the locals could come together and interact on a social level. It is no coincidence that, very often, business leaders became community leaders, as they possessed an intimate knowledge of the people they served.

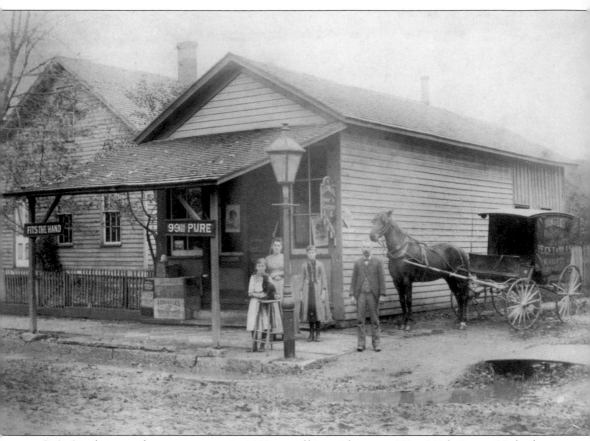

R.G. Single opened a grocery store in 1882 out of his residence on West High Street. He built up a loyal clientele who purchased the quality fresh eggs, butter, and dry goods he made available, frequently delivering them in the wagon shown to the right in this 1880s photograph. By 1910, Piquads had their choice of 44 grocery stores.

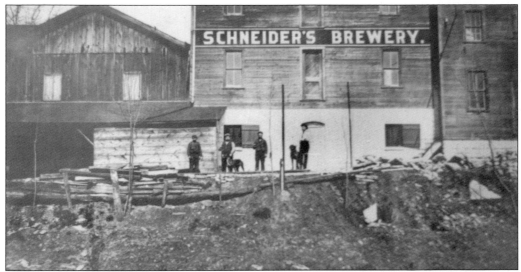

The growing numbers of German immigrants moving into the area during the 19th century included brewmasters anxious to put their skills and experiences to good use. John Suttle opened one of the earliest-recorded breweries in Piqua in 1835 on an island in the Great Miami River. Other breweries followed, including Schneider's Brewery, shown here around 1890, which opened in 1881. Harry Schneider, a prominent Piquad, oversaw the production of his distinctive lager in this three-story frame building.

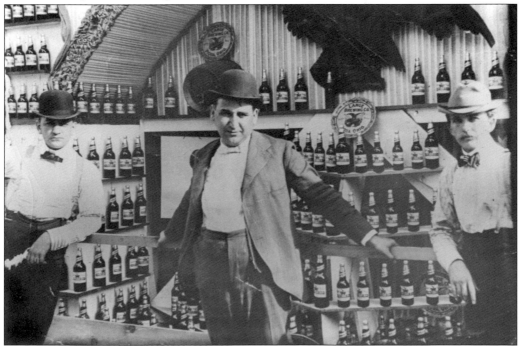

Brewers found the waters of the Great Miami River to be particularly favorable to their craft. Local springwater also provided the ice used to refrigerate beers during the warmer months. Thus Piqua's breweries tended to be located near the river, such as Karl Kaiser's Ash Street Brewery and the Lange Brewery, shown here in the late 1800s. The Lange Brewery, later Lange Products Company, enjoyed success for many decades, opening a bottling plant in Piqua in 1936.

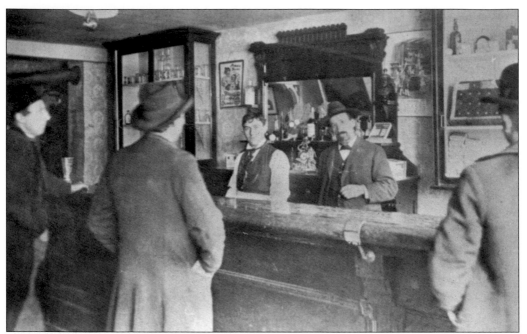

The growing number of breweries in southwest Ohio encouraged the establishment of bars and saloons, such as Schnell Bros. Saloon, shown here in 1902. It also fostered the growth and activism of anti-alcohol organizations like the Women's Christian Temperance Union and community groups like the YMCA and YWCA.

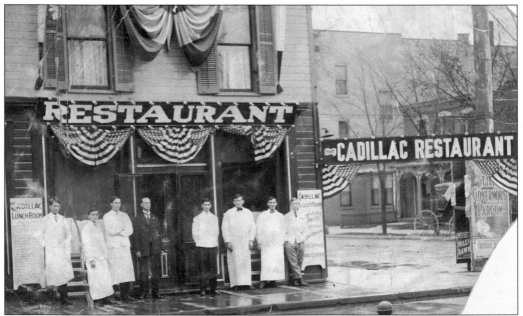

In the early 1900s, the Cadillac Restaurant, located on the corner of Wayne and Market Streets, offered a generous "businessman's lunch" to its noontime customers at an economical rate: meats, stews, fish, bread and butter, vegetables, and a choice of coffee, milk, or tea for 14¢. Additional side dishes could be purchased for 3¢. The Cadillac's proprietor, Henry May, opened the restaurant in 1905 after managing restaurants in Chicago.

Piqua's growing and increasingly cosmopolitan population in the late 1800s created a demand for greater access to consumer goods. Pictured at right as it appeared in 1893, J. Frank Groff's Buffalo Store, located on North Main Street, and F.M. Kirby & Co. 5 and 10¢ Store, shown below at roughly the same period, offered a wide variety of merchandise for Piqua shoppers. Groff's specialized in fabrics for fashion and decorative purposes, while Kirby's boasted a wide array of readily affordable items for purchase.

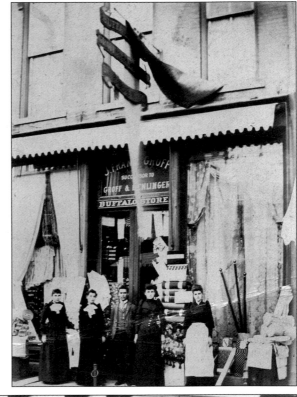

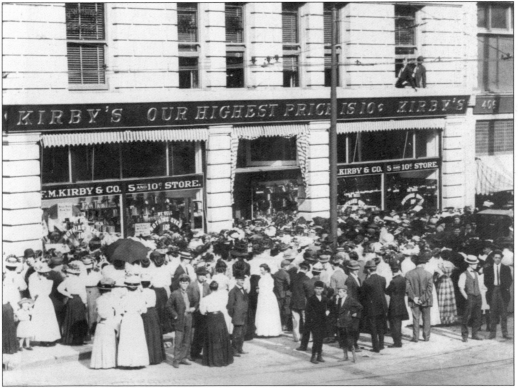

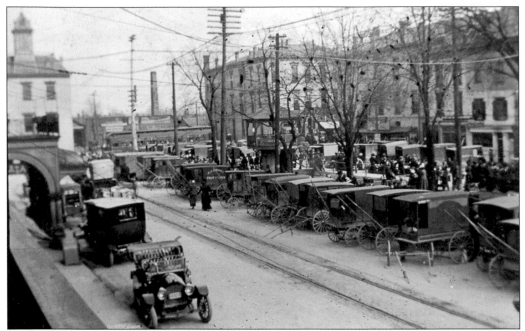

A line of delivery wagons signals a market day held in the public square around 1910. The practice of area farmers bringing their produce to sell in town dates to the early 1800s and provided Piquads with easy access to food before the advent of grocery stores. Market days occurred all day on Wednesdays and Saturdays.

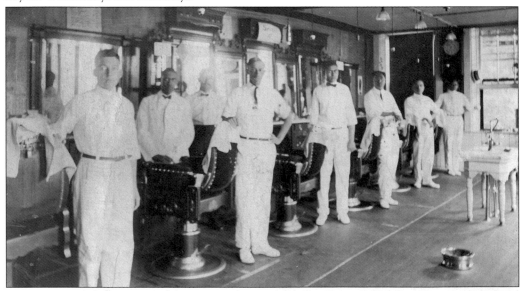

Cassie Evans's barbershop, seen here around 1910, was one of Piqua and Ohio's largest, with seven chairs. One of his barbers, Leslie Wall, an African American resident, shown second from left, worked for Evans for 17 years. He started out shining shoes and stepped in to substitute for an absent barber. Wall's skill was such that he opened his own barbershop (the state's first barber-beauty shop) and later managed an appointment-only shop in the Orr-Flesh Building for 36 years. Wall also contributed to the community through involvement in such organizations as the YMCA, chamber of commerce, and Miami County Mental Health Association.

A number of barbershops attempted to make a go of things in Piqua over the years. F.A. Young, a self-taught barber, opened the Favorite Barber Shop on North Main Street in 1889. Young's shop featured three chairs, walnut fixtures, and a marble top. Other three-chair barbershops in the late 1800s were A.J. Johnson's, also on North Main, and Karsen and Schemmel's shop on Market Street. This photograph shows Raglin's Barber Shop on High Street in the 1930s. Pictured from left to right are Garfield Hughes, L.G. Raglin, and Leslie Wall.

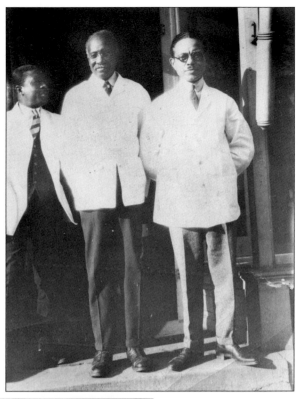

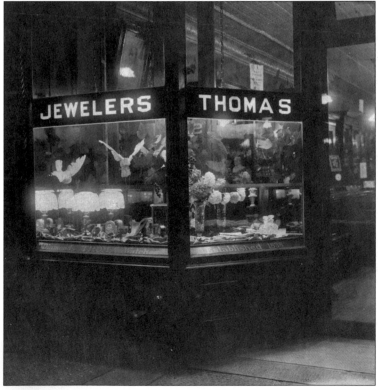

The legacy of the Thoma family in Piqua begins in 1838, when a young German immigrant named Augustine Thoma relocated to Piqua from New York City and founded a jewelry store on North Main Street. Until his death in 1899, he was a prominent figure as a businessman and civic leader, setting a pattern for his descendants. Joseph, his grandson, took over the jewelry store and served as mayor of Piqua during the 1940s, thus carrying on the family tradition. Today, Thoma's is one of the oldest family-owned businesses in Ohio still in operation.

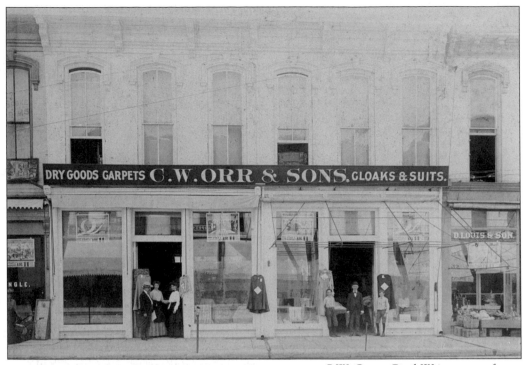

C.W. Orr, a Civil War veteran from Indiana, opened a dry goods store on North Main Street between Ash and Greene Streets during the 1880s. His older brother, William Perrine Orr, cast a larger shadow than C.W., having acquired a fortune in the California Gold Rush in the 1850s and then founding a linseed oil company. He was a titan in Piqua business and Ohio politics.

The H.H. Schroerluke Cigar Manufactory on West High Street made tobacco and cigars available to Piqua's smokers starting in the mid-1850s. William Schroerluke, the founder and owner, produced tobacco and sold cigars before passing the operation on to his sons. The store closed in the early 1900s.

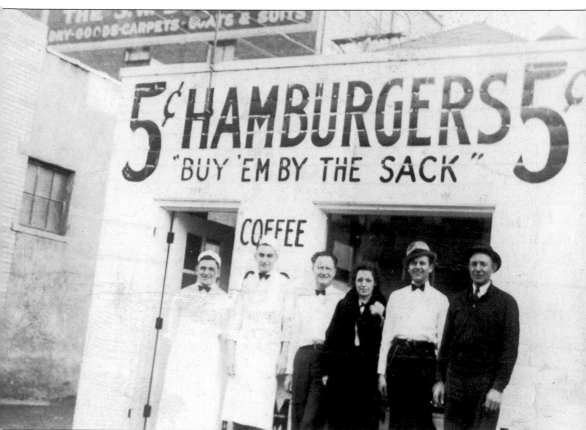

The tiny LoRa Hamburger Shop on West Ash Street, seen here in the 1920s, offered its customers hamburgers for 5¢ (later sold by the sackful) in addition to homemade soups and milkshakes. Customers also came to the LaRo in the morning hours to enjoy a quick breakfast of donuts, cereal, juice, and coffee. The restaurant was open 24 hours a day, except Sundays. Its proprietors prided themselves on the speed and efficiency with which the food was prepared and the cleanliness of the establishment in which it was served. In the mid-1940s, when Charles Murray managed the LoRa, the restaurant underwent renovations.

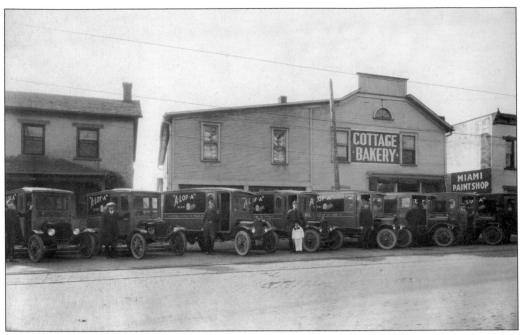

This fleet of delivery trucks emblazoned with the "A-Lof-A" Miami logo speaks to the rapid success of the Cottage Bakery by the early 1920s. V.R. Osborn started the bakery with a single oven in November 1919 in the back of a grocery store and provided fresh loaves to other local grocers.

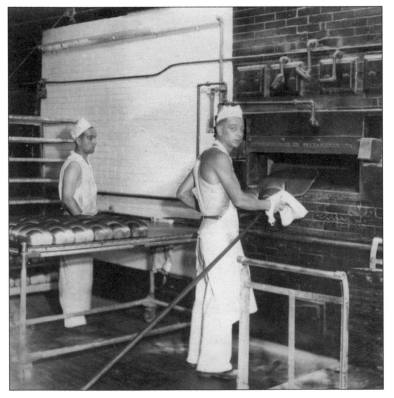

The growing number of customers necessitated the Cottage Baking Company relocating in 1920 to the former Knoop Bakery, with its two available brick ovens. As the business expanded, Cottage delivered bread to customers over a 25-mile radius. In this photograph from the early 1920s, employee Blaine Carder (right) tends to his oven.

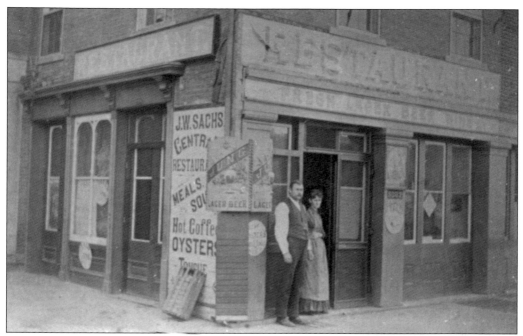

Pictured here is Sach's Restaurant as it appeared in the late 1800s. The lager beer and wine advertised so prominently outside the restaurant suggests how prevalent the production (and consumption) of alcohol had become in Piqua by the closing decades of the 19th century.

One of many grocers in Piqua's history, Morrow's Grocery is visible here on Covington Avenue as it appeared in the 1930s. The Colored Men's Cooperative Trade Association of Piqua, founded in 1867 by a group of African American businessmen, is another grocery store of note. The group bought and sold groceries, produce, and dry goods on behalf of Piqua's black population. It was the first company in Piqua owned by African Americans.

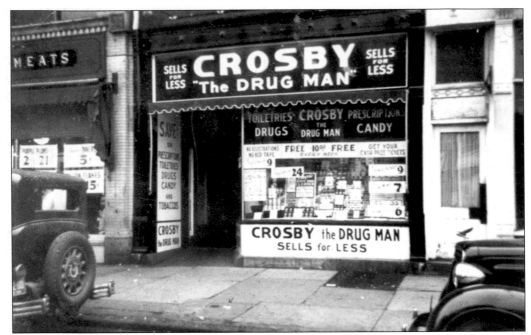

Like so many businesses in Piqua, drugstores made their first appearance in the 1830s, when canal construction was in full swing. Moses Mitchell is credited with running the first drugstore, located on Main Street. By the mid-1900s, drugstores like Crosby "The Drug Man" on North Main Street offered candy and reading materials in addition to prescriptions.

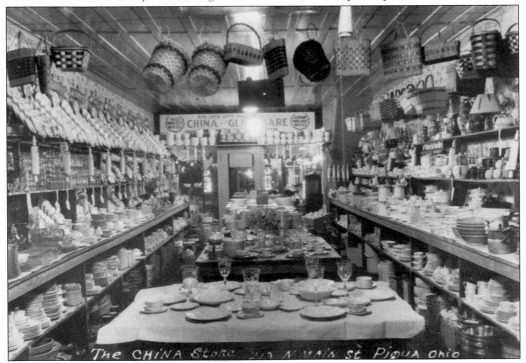

The China Store at 213 North Main Street during the 1930s and 1940s is another example of the many locally owned businesses to line Piqua's main thoroughfare.

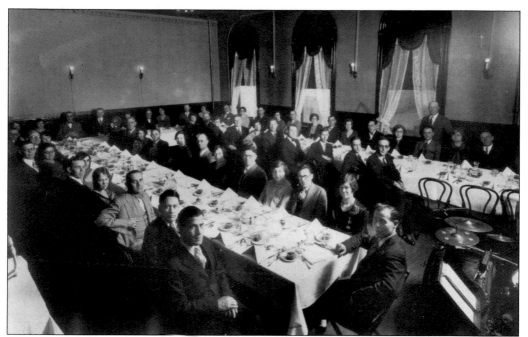

This unidentified group from the 1930s is pictured in the midst of a meal served to them in the Ordinary Dining Room at the Favorite Hotel. Initially built as the Plaza Hotel in the 1890s, the Favorite offered Piqua's finest lodgings for its guests as well as fine dining on the fourth floor. Today, the fourth floor is used for meetings and receptions.

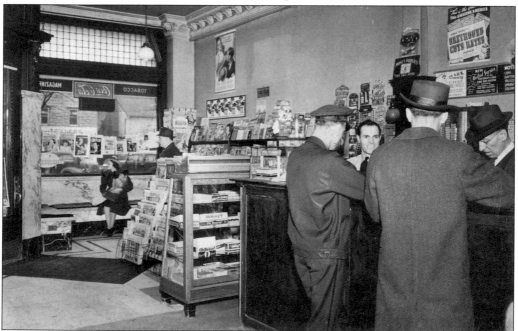

The Favorite Hotel housed a number of businesses during its years of operation, ranging from barbershops to restaurants and taxi services. One of the longest-operating businesses in the hotel was the Dodge Taxi Company, which managed cabs and buses running throughout the city. This photograph shows the interior of the Dodge Taxi and Bus Terminal.

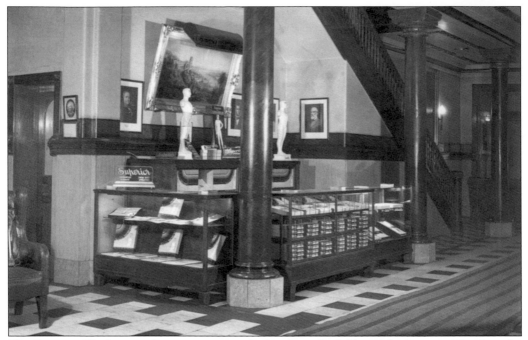

The Superior Underwear Company operated a kiosk in the lobby of the Favorite Hotel in the 1930s. While a testament to the ubiquitousness of underwear manufacturers in Piqua, the kiosk also offered hotel guests the opportunity to pick up a souvenir before returning home.

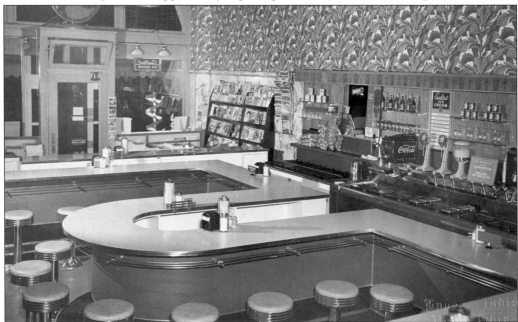

The Bus Station Café of the Favorite Hotel, shown here in 1949, was the location of a sit-in organized by the Piqua chapter of the NAACP in 1945. A group of African Americans took their seats at the lunch counter in the café, an establishment that refused service to blacks. The sit-in ended successfully with the management deciding to serve the protestors. Such tactics became commonplace during the height of the Civil Rights Movement in the 1950s and 1960s.

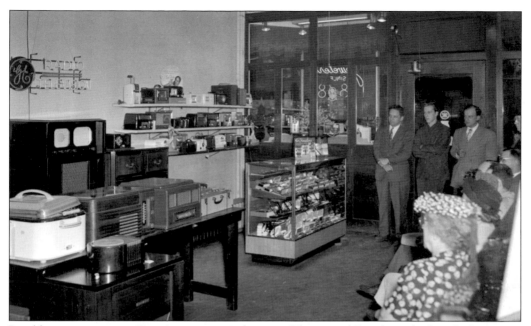

In addition to serving as Piqua's premier jewelry store, Thoma and Sons branched out by becoming the first television retailer in 1948. Although available since 1939, commercial televisions remained well beyond the financial reach of ordinary Americans. Pictured here is Piqua's first television reception on April 13, 1948, during which customers could view the medium when it was still very much a novelty.

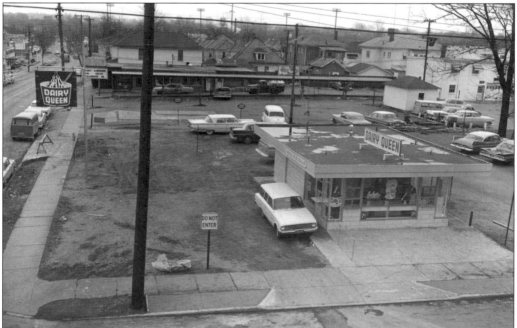

A Dairy Queen opened in Piqua during the 1960s. This photograph was taken during that time, with Frisch's restaurant visible in the background. Dairy Queen later became George's and, half a century later, continues to operate on Ash Street, serving ice cream treats and hamburgers to the people of Piqua.

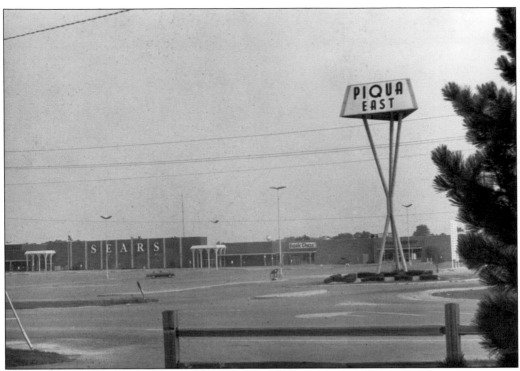

The phenomenon of shopping at indoor malls spread to Piqua in the late 1960s when construction began on the Piqua East Mall at the intersection of US 36 and Looney Road. The mall's grand opening occurred in November 1969, with most of the 19 storefronts ready for business. A second mall, the Miami Valley Centre Mall, opened in Piqua in 1988. This photograph of the Piqua East Mall is from the 1980s. The structure is now a shopping center.

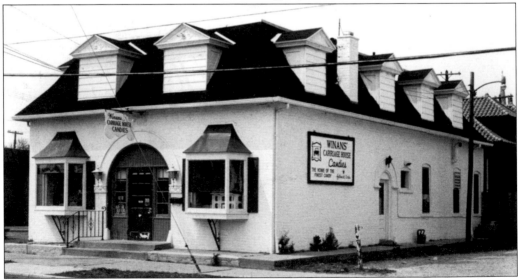

Winans Candies, like Thoma's Jewelry, is one of Piqua's oldest businesses, having been in operation since the late 1800s. Now in its fourth generation of family ownership, Winans continues to offer fine chocolates and coffee at two locations in Piqua, one on West High Street and a newer one on Looney Road, as well as nine others across Ohio.

Five

SPORTS

There may be no better display of community spirit than competing on behalf of one's hometown. Piqua has a rich tradition of sports teams representing its schools, its civic organizations, and its corporations. Even the ongoing rivalry with Troy persists to this day. Piqua's sports have also given the city its share of local heroes and legends, some of whom are featured here, setting records, leading teams to championship seasons, and going on to careers in professional athletics.

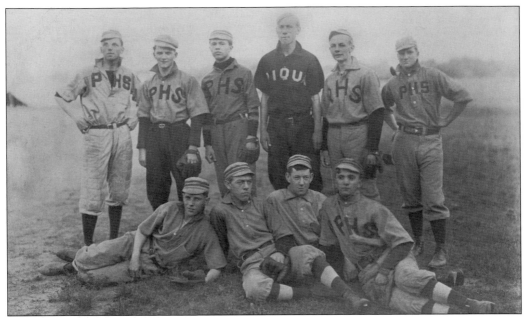

Piqua High School fielded its first baseball team, the Athletes, in the late 1870s. The 1905 team is pictured above. It took two decades before the high school assembled a football team in the late 1890s. C.W. Bassett, the secretary of the Piqua YMCA, and Edward H. Allen organized the team, with Allen serving as its first coach. The team played its first game against Troy in 1899, which ended in a defeat for Piqua, 17–0, and sparked a rivalry between the two schools that has continued unabated ever since. The 1906 football team is shown below. Piqua won the state championship in 1915 and again in 2006. The 1915 trophy disappeared before resurfacing in 2003 in an online auction, when it was purchased and restored to the high school.

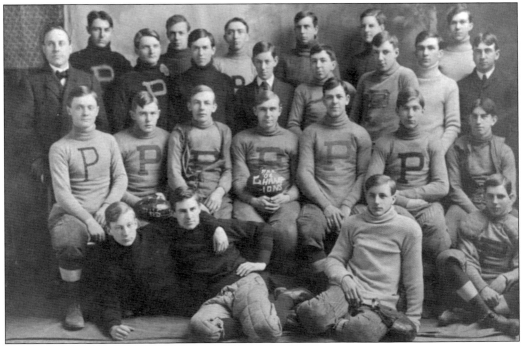

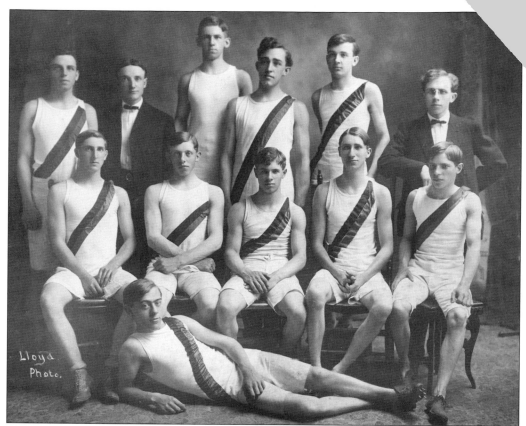

Piqua High School students also competed on the track team. Above is the 1905 team and its coaches. In addition to high school athletics, local semiprofessional sports teams offered opportunities to Piquads. High school students frequently played for these teams, often under assumed names to avoid jeopardizing possible college athletic scholarships. One such semipro team, the Piqua baseball team, is seen below around 1910. A number of similar teams appeared in the early 1900s.

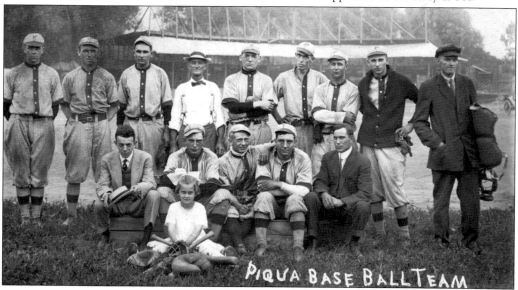

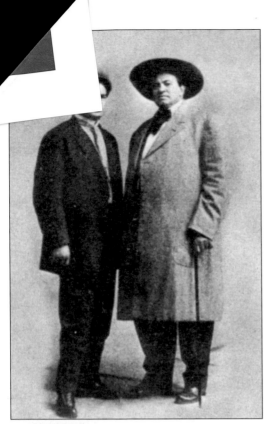

Luther "Lute" McCarty (left) is shown with his father, Dr. Aaron P. McCarty, in 1913. Both achieved a level of prominence in the Piqua area. Aaron, a resident of Piqua, ran a medicine show and sometimes identified himself as a Native American named White Feather. Luther, a professional boxer, won the title of the white heavyweight champion in 1913, after a checkered past as a drifter in Australia, South America, and the United States.

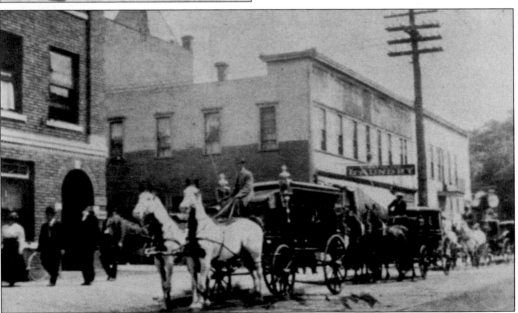

Luther McCarty began fighting professionally in 1911 and quickly gained recognition for his flashy public persona and boastful ways. He died in May 1913 after receiving a blow to the jaw during a fight with Arthur Pelky in Calgary, Alberta. He was only 21 years old. His father buried him in Piqua following a viewing and funeral procession (seen here) that attracted thousands from the area. Aaron McCarty died in 1934.

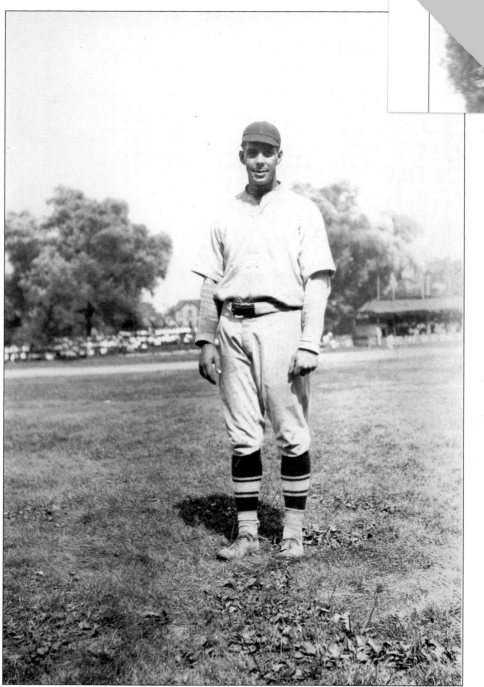

Jim Ginn was one of Piqua's outstanding athletic figures during the early 1920s. During his high school years from 1917 to 1920, Ginn earned five letters in football, baseball, and basketball and won the all-points medal at Miami Valley's first track meet. He played on Keifer drugstore's semipro football and basketball teams. He also played for the City League baseball team and the Purol Peps softball team during the 1930s. A lifelong area resident, Ginn was a regular attendee of Piqua sporting events and was inducted into the Piqua Athletic Hall of Fame in 1995. Ginn posed for this photograph in 1920.

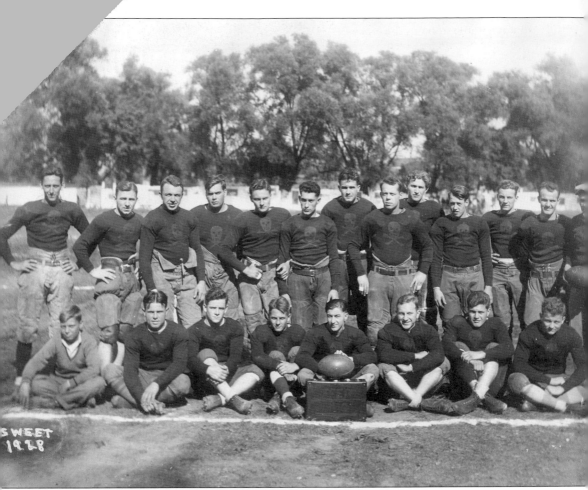

Wilson W. Wood organized Piqua's first football team and acted as its coach in 1896, two years before the Piqua High School football team first took the field. Semiprofessional football teams, such as the one pictured here, were prevalent in the Miami Valley during the 1920s. Piqua had two regional semipro teams, the National Cavalry Guard Team and a team sponsored by Charles Kiefer of the Kiefer drugstore.

This Indian statue stood in the lobby of Piqua High School for several decades. The high school adopted an Indian as its mascot in 1928 after competing in athletic events under various other names, including the Red and the Blue. The mascot continues to the present day, though not without controversy and debate as to the appropriateness of using groups of people as mascots. Of great concern to many is the way Native Americans are often stereotyped through such representations. This statue now resides on the fourth floor of the library.

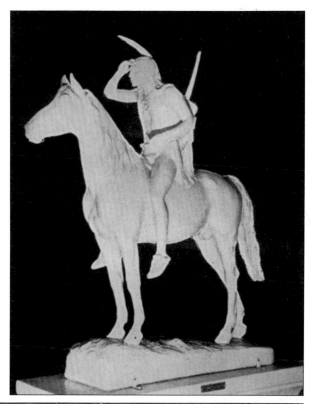

The aforementioned semipro football team sponsored by the Kiefer drugstore was not the only local sports team with corporate sponsorship. Numerous Piqua companies supported such teams as a means of strengthening bonds between workers. The Cron Company, a furniture manufacturer, backed a baseball team that won the Industrial League Championship in 1922.

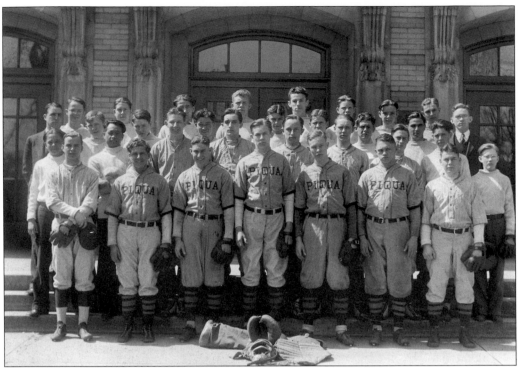

The baseball team of Piqua High School stands on the front steps of the school above, a pose repeated by the basketball team below. These pictures were taken in 1930, only two years after Piqua High School became the Indians, as displayed prominently on the sweaters of the basketball players.

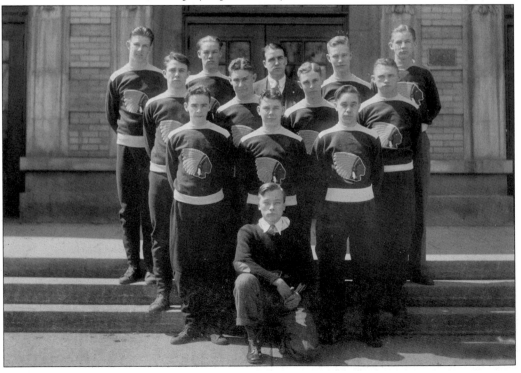

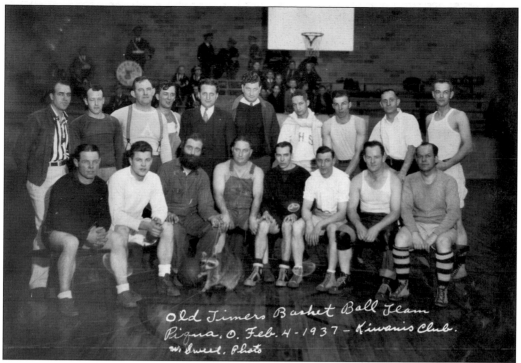

The Kiwanis Club of Piqua made athletic participation possible for those no longer in high school as well as those still in grade school. The amusing photograph above from 1937 of the Old-Timers basketball team shows their more lighthearted approach to the game, as they are seen posing with a raccoon. Below are the 1953 Kiwanis Little League baseball champs. The participation of both white and African American players suggests that, in the field of sports, segregation broke down ahead of other organizations and institutions.

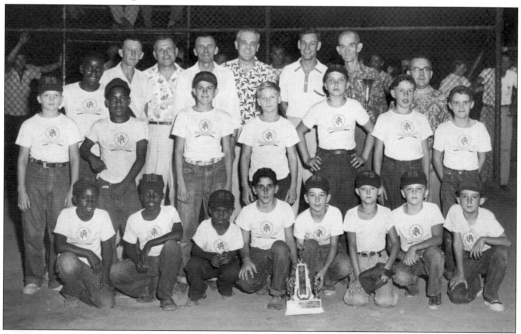

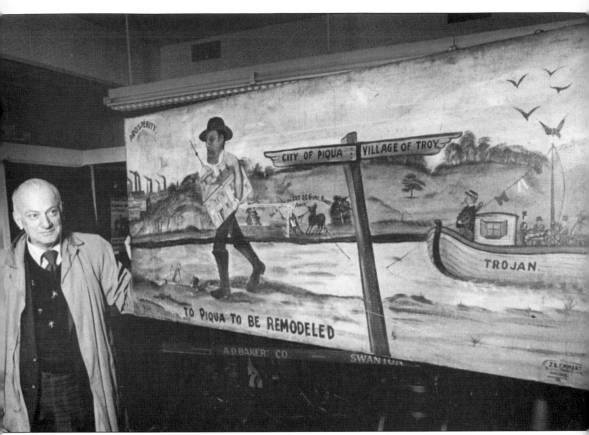

It is no secret that Piqua and Troy have been rivals on the playing field for generations. What residents of these communities may not be familiar with are the political debates between Piqua and Troy that informed and exacerbated tensions that carried over into sports. This rivalry started in the 1820s and 1830s, when leaders in both towns fought to have easier access to the Miami Canal. It continued during the remainder of the 19th century through debates over which community would serve as the county seat. After much squabbling, Troy ended up winning the argument, due in large part to its more central location within the county. In this photograph from the 1940s, Piqua mayor Joe Thoma poses in front of an 1884 painting based on a political cartoon. The image depicts a thriving Piqua in which industry and manufacturing dominated, making reference to another point of argument made by Piqua leaders to support relocating the county courthouse to Piqua. This painting is now located in the local history department of the Piqua Library.

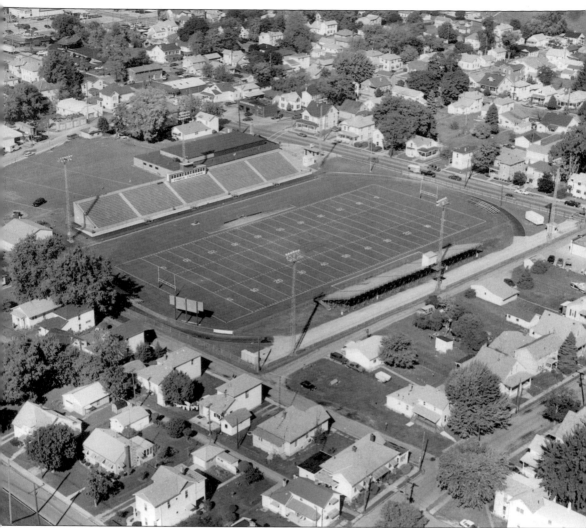

In 1968, the stadium at Roosevelt Field, seen here in a recent photograph, was renamed Wertz Field after Piqua Central High School's football coach from 1925 to 1950, George Wertz. During this period, Wertz's teams won an impressive 165 games, including two undefeated seasons in 1926 and 1947. Wertz had only four losing seasons during his tenure. His son George Jr. played quarterback for him and went on to play for Ohio State in the 1940s, following World War II.

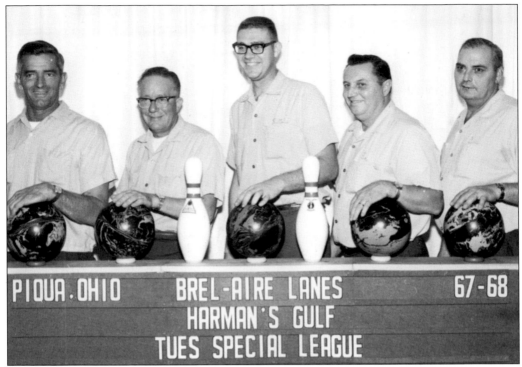

PIQUA·OHIO BREL-AIRE LANES 67-68
HARMAN'S GULF
TUES SPECIAL LEAGUE

The Piqua city council attempted to thwart the establishment of bowling alleys inside city limits throughout much of the late 1890s, as the sport was initially associated with the sort of rough-and-tumble men who frequented saloons and dance halls. When bowling did take root by the start of the 20th century, it had broad appeal irrespective of socioeconomic status or gender. Bowling leagues for both sexes flourished in Piqua until the 1970s. Brel-Aire Lanes opened in 1959 and offered bowling leagues for men and women, as shown by these photographs taken in the 1960s.

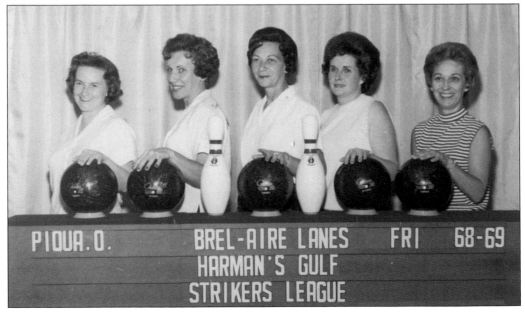

PIQUA·O. BREL-AIRE LANES FRI 68-69
HARMAN'S GULF
STRIKERS LEAGUE

Six

COMMUNITY ORGANIZATIONS AND CLUBS

Civic organizations affiliated with churches, professions, and activities have been a critical component of defining Piqua as a community. The Kiwanis and Rotary Clubs strive to improve the lives of those stricken with illness or poverty, while the YMCA and the YWCA promote rigorous physical activity for the young, the hope being that a strong body might foster a sound mind and virtuous spirit. Regardless of the focus, Piqua's past and its present involve the concerted efforts of residents willing to go the distance when it comes to strengthening community ties. The following pages are not nearly enough to give Piqua community organizations the credit they deserve, but nonetheless, it is an attempt.

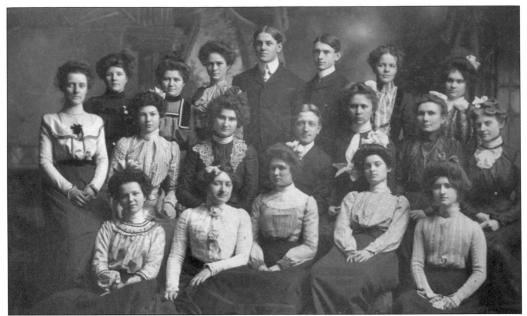

The Piqua YWCA grew out of a perceived need for organizations geared towards the young women who were working in factories, notably the underwear industry. This image includes several of the charter members, who were employees from the Superior Underwear Company. The YWCA reorganized and expanded the Piqua branch in 1919, after years of fundraising activities. The branch was initially headquartered at a facility on North Wayne Street, with Lucy Patterson serving as the first president. (Courtesy of the Piqua YWCA.)

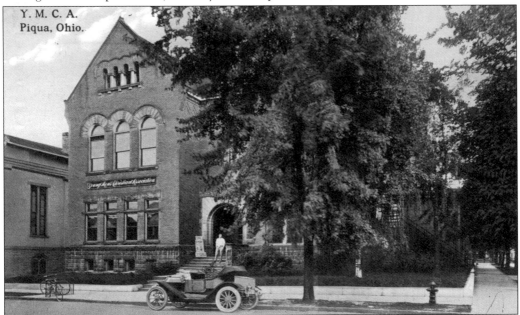

Located on the southeast corner of High and Downing Streets, the YMCA building is visible here as it appeared in 1914. The YMCA organized the Piqua branch in 1877 and underwent an extensive reorganization in 1891. When this photograph was taken, the YMCA had occupied the building for 20 years.

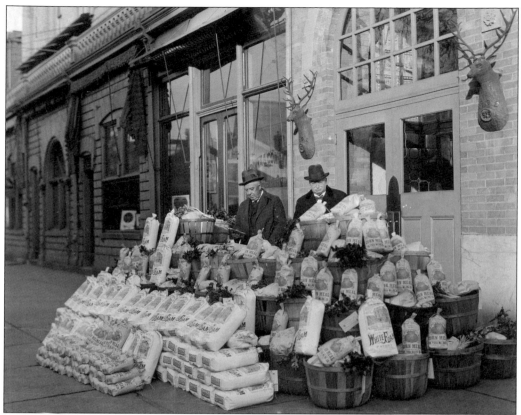

Here, just outside their meeting hall, members of Piqua's Elks Lodge 523 distribute Thanksgiving baskets filled with flour and cornmeal from the Piqua Milling Co. The Benevolent and Protective Order of Elks allowed a Piqua branch of 67 charter members to be formed in 1899. The lodge gained many new members over the years, allowing it to take part in numerous charitable projects, including a Christmas party for local children.

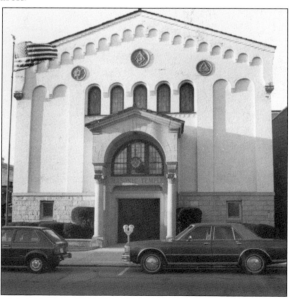

The Piqua Masons first met at a local tavern in the 1840s and continued to use this meeting space until 1854, when two brothers, Joshua and J.E. Worley, made a two-story building available, to which the Masons added an additional floor. In the late 1920s, the Masons purchased and converted a former Baptist church on West High Street to serve as their new temple.

This c. 1980 photograph depicts the former Salvation Army Citadel on South Wayne Street. The Salvation Army first came to Piqua in 1887, when Captain and Mrs. Hinton rented rooms in Border Hall, located at the corner of Main and Greene Streets, for Sunday services and nightly meetings. Disruptive behavior at these events dissuaded the Hintons from staying. The Salvation Army gave Piqua another chance from 1905 to 1911 but initially found the activism of the local churches made its presence unnecessary.

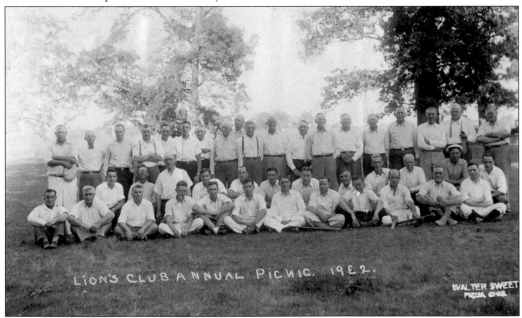

The Piqua Lions Club was chartered in 1920, three years after the creation of the organization in Chicago. The group sought to promote humanitarianism on a local and international scale. Members of the Lions Club gather for a photograph while attending their annual picnic in 1932.

The woods and waterways surrounding Piqua encouraged generations of outdoors enthusiasts. The Piqua Fish and Game Protective Association (or Piqua Fish and Game Club) formed in 1920 and set a standard for similar clubs to follow. It stocked nearby lakes and ponds with fish and released pheasants in protected woods so as to prevent the birds' extinction. These hunters displaying their trophies in the public square in 1937 are, from left to right, Niels Lundgard, D. Roberts, Albert J. Berberick, George Grunert, and unidentified.

The Piqua chapter of the Daughters of the American Revolution (DAR) created this float for the 1938 sesquicentennial celebration to commemorate the enduring contributions of pioneer women. When these women arrived with their families during the late 1700s, the area was still part of the Northwest Territory. The DAR organized the Piqua chapter in 1896 and remains an active and vital organization in the area.

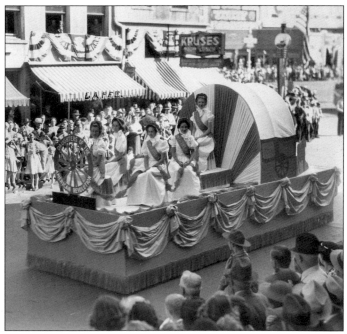

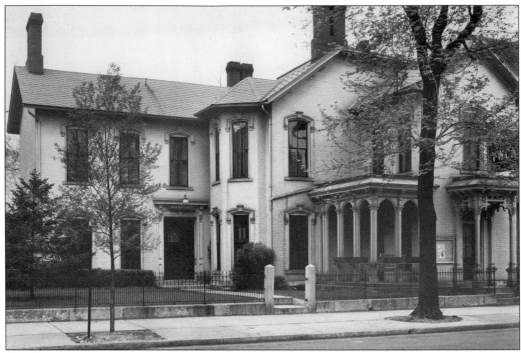

This pair of photographs shows the YWCA building on North Wayne Street (above) and the YMCA building on High Street (below) in 1939. Both organizations struggled with reduced budgets during the years of the Great Depression but continued to offer a variety of programs to members and their families throughout the years. The Piqua branch of the YMCA managed to raise the funds necessary to complete a series of improvements and renovations that included additions to the clubrooms, swimming pool, and handball court. (Above, courtesy of the Piqua Public Library Local History Department; below, courtesy of the Miami County YMCA.)

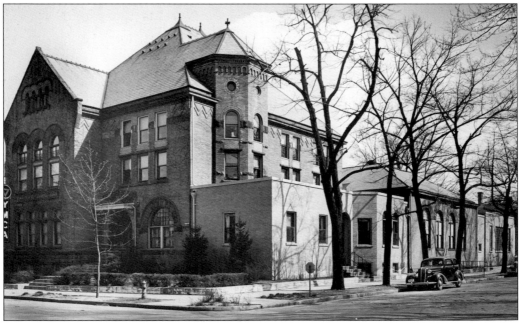

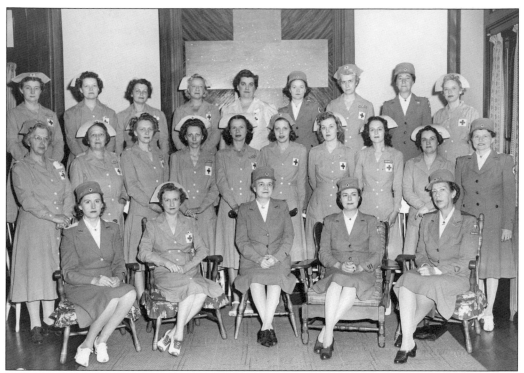

Like other service organizations, the American Red Cross became more prominent in Piqua following the 1913 flood and set about preparing residents for any future crises that might arise. The Northern Miami Valley chapter of the Red Cross came together in May 1917, during the early stages of the Spanish Influenza pandemic. When World War II began, members of the Piqua chapter, such as those in this 1945 picture, were chosen to make thousands of surgical dressings for the US Army.

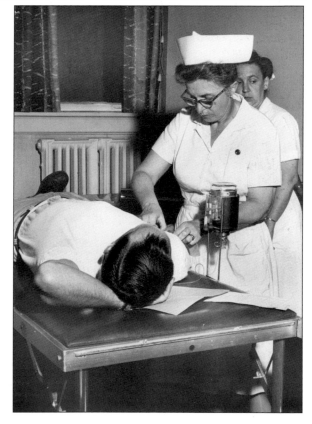

The Piqua chapter of the Red Cross had previous wartime experience providing surgical dressings, bandages, and clothing for US soldiers during World War I. Their role expanded during World War II with the addition of the National Blood Donor Service for wounded servicemen. The nurse in this 1945 photograph is taking life-giving plasma from a donor.

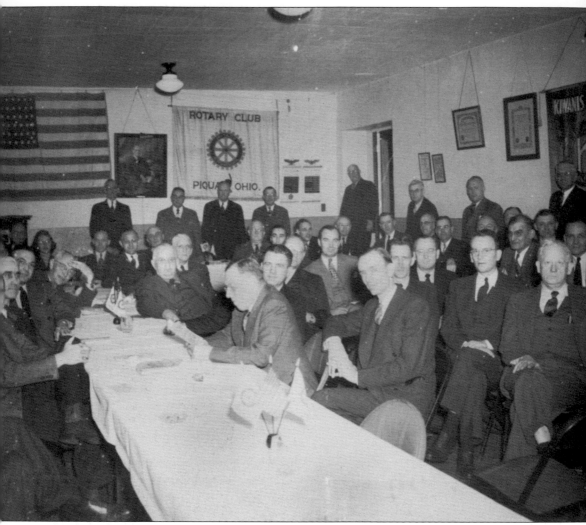

The devastation wrought by the 1913 flood sparked an interest in the formation of more organizations committed to improving the community. In this spirit, the Rotary Club of Piqua was established in October 1914 with only five members and chartered in January of the following year. The Piqua chapter has the distinction of being the first Rotary Club founded in a city of less than 20,000. Its viability and vitality proved that the organization could thrive outside of large urban centers and refuted the Rotary International's initial rejection of the club's application. The Piqua Rotary Club was the first to arrange a Rural-Urban meeting. It made its mark working with local handicapped children and continues to participate in benevolent community service, now a century since its creation. In this 1944 photograph, the Rotary holds a meeting at the YMCA.

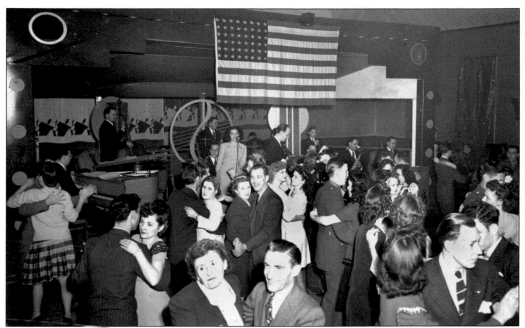

In these pictures, the Winter Garden Dance Hall hosts a United Service Organizations (USO) dance on November 11, 1944, commemorating Armistice Day. During warmer months, the open-air Knights of Columbus roof garden was the location for such dances. The USO also held dances at the Elk's ballroom every other week. Such wartime festivities did much to bolster local morale and provide an outlet for young men on leave from the front lines and young women toiling away on local assembly lines to produce propellers, bomb sights, parachutes, and other essential wartime items. During World War II, the USO and Red Cross worked to raise over $35 million in war bonds with the stalwart assistance of local businesses, social organizations, and professional groups.

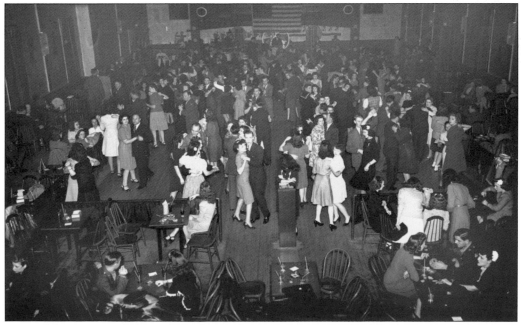

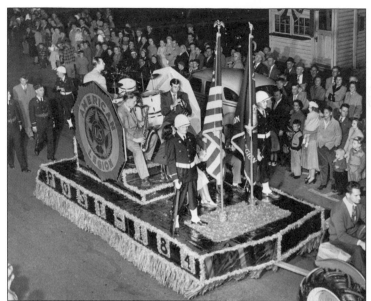

The American Legion Post 184 offered up this tuneful contribution to the 1949 Corn Festival Parade. Post 184 undertook greater community involvement after World War II by sponsoring egg hunts at Easter and parades at Halloween and arranging visits to the infirm at Christmas. In 1946, Post 184 completed construction of a Veteran's Memorial Home and relocated from the basement of the Favorite Hotel to its current address on West Water Street.

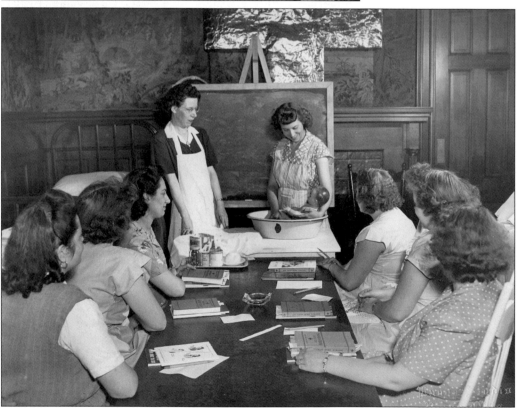

Piqua's branch of the Red Cross hosted home nursing classes such as this one in 1949. The return of millions of servicemen at the conclusion of World War II preceded America's baby boom of nearly 80 million new children before 1964. Local women who had learned life-saving skills from the Red Cross during the war years now learned how to take care of the baby boomer generation.

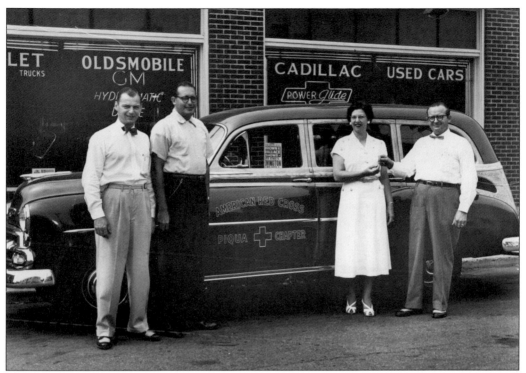

In this 1950 photograph, the Sherer-Bell Automobile Agency, one of Piqua's largest car dealerships at the time, donates a new car to the Piqua chapter of the Red Cross, which oversaw various manners of training and safety education, such as lifesaving and first aid in the postwar era.

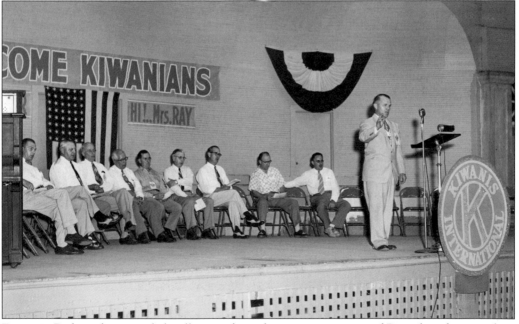

Fountain Park, with its wooded walking paths and open spaces, attracted Piquads seeking outdoor recreation. The Kiwanis organized picnics for its members and their families in the park during the 1950s. In this photograph, Hance Pavilion serves as a stage for a speaker at such a picnic.

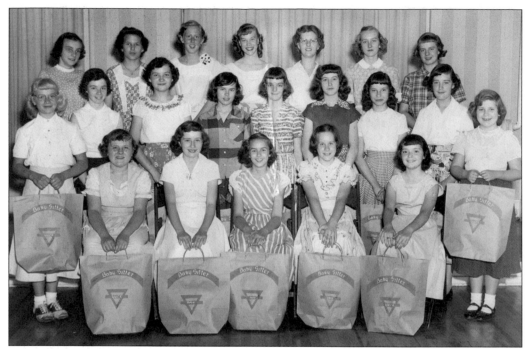

The young women of Piqua found in the YWCA an organization that offered them guidance and training as they matured. Like the Piqua chapter of the Red Cross, the Piqua YWCA made babysitting classes available. The girls of a 1951 class above learned the fundamentals of first aid and discipline that enabled them to look after small children with greater confidence. Below are YWCA members about to become Senior Triangle participants at a recognition ceremony in the 1950s. From its beginning, Piqua's YWCA was divided into groups according to different corporations, such as the Atlas Underwear Company and the Orr Felt and Blanket Company, offering sponsorship for membership to the female employees of these companies. (Above, courtesy of the Miami County YMCA; below, courtesy of the Piqua YWCA.)

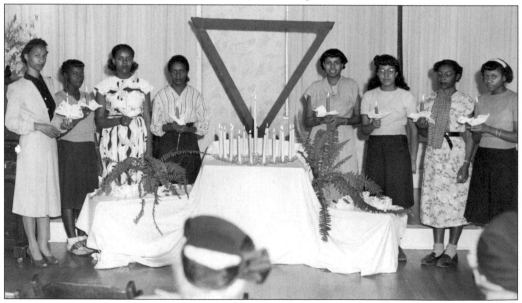

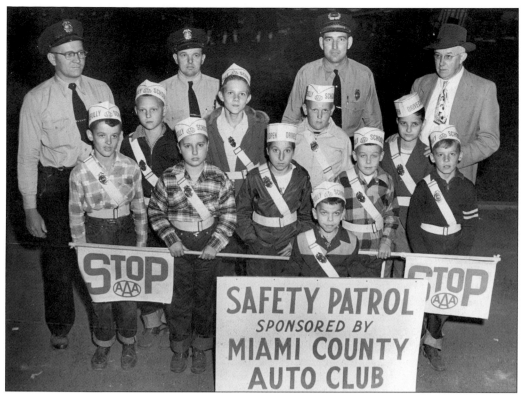

Members of Piqua's school patrol (above) received their training from the police force, courtesy of the Miami County AAA. Below, members of Piqua's Salvation Army take up a collection in the city square around 1960. The Salvation Army returned to Piqua in late 1923, after two previous failed attempts. Upheaval caused by the Great Depression and World War II presented the Salvation Army with no shortage of opportunities to provide hope and comfort. The Salvation Army opened a new chapter in 1954.

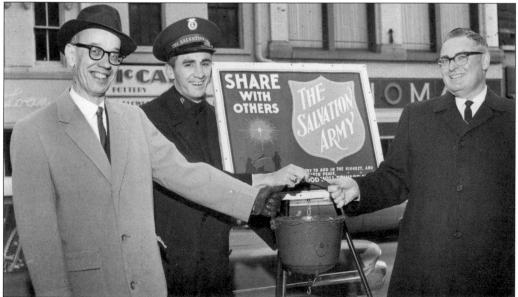

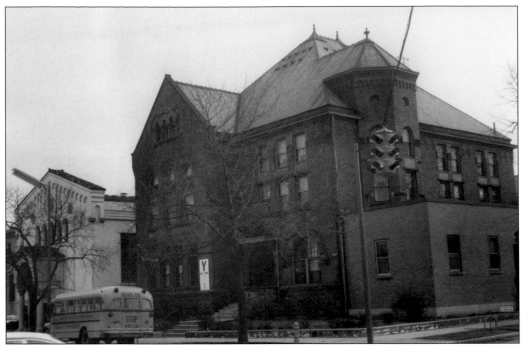

This picture shows the original YMCA building in 1962, shortly before its destruction and the construction of a new building. The addition completed during the 1930s is visible on the right. (Courtesy of the Miami County YMCA.)

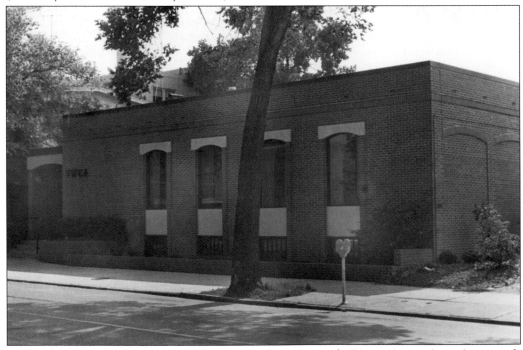

This image from the 1980s of the YWCA building on North Wayne Street shows how much expansion and alteration changed the original layout and appearance of the structure since the organization had first moved in six decades before. (Courtesy of the Piqua YWCA.)

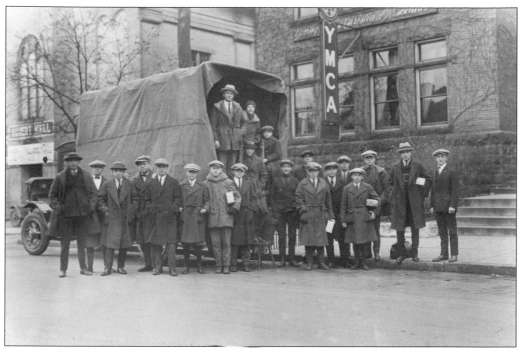

The YMCA has offered excursions as part of its programming since the organization's inception in Piqua. These excursions include day trips for members, as exemplified in the above image of a group departing for an Ohio State football game around 1910. The YMCA has also offered overnight trips to members, including a trip to Mammoth around 1910, shown below. Other travels included fishing excursions to Temagami and trips to Yellowstone. In the 1980s and early 1990s, the YMCA offered youth excursions to children 8–12 years of age. These annual weeklong trips traveled to various destinations, including New York City, Chicago, Toronto, Charleston, and Washington, DC, via the YMCA bus. (Both, courtesy of the Miami County YMCA.)

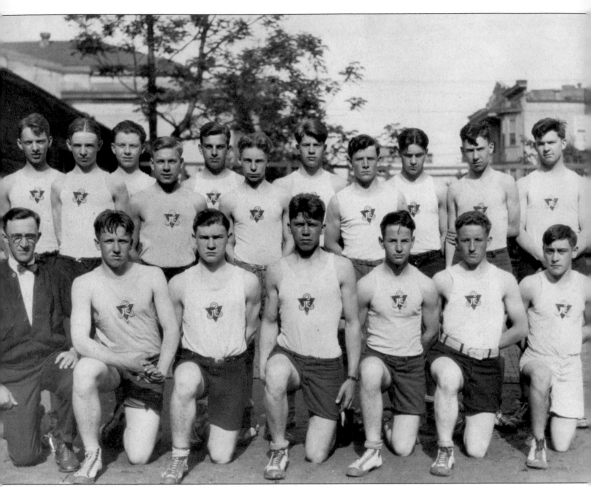

The YMCA Leaders Club has, for years, provided opportunities for the area's youth to become involved in serving their communities. In its early years, the club was referred to as the Junior Leaders Corps; pictured here is the Junior Leaders Corps from 1925. Focusing on developing leadership skills, the program offers youth volunteer opportunities in the community, as well as spiritual and mental growth. Members of the present-day Leaders Club volunteer not only at the YMCA but also in the Piqua community and participate in training opportunities such as the regional Leaders Training School, held annually. (Courtesy of the Miami County YMCA.)

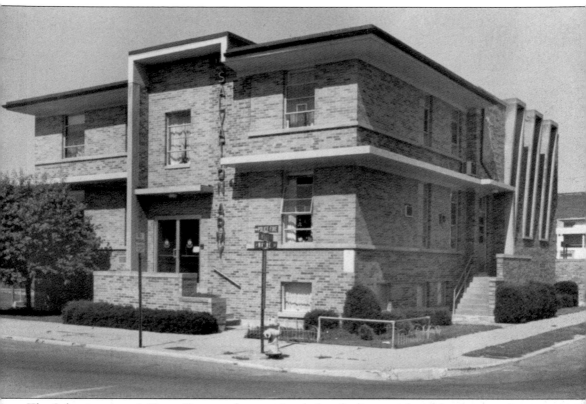

The Salvation Army's Piqua Corps took some time before finding a niche and permanent home in the community. In the 1930s, the Piqua Corps moved from its headquarters on South Main Street to a building on South Wayne Street. In the mid-1950s, the corps built a new citadel, the modern-looking structure in this 1987 photograph.

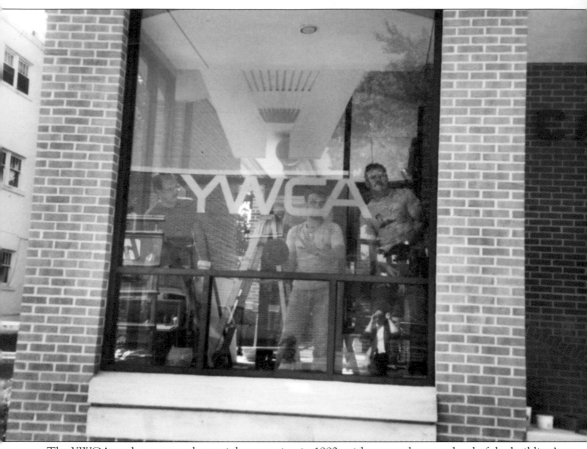

The YWCA underwent a substantial renovation in 1992, with a complete overhaul of the building's facade. The upgrades, which included accessibility ramps, resulted in the YWCA being the first building in Piqua compliant with the Public Accommodations section of the 1990 Americans with Disabilities Act. (Courtesy of the Piqua YWCA.)

Seven

PARKS AND RECREATION

The natural beauty of Piqua's setting has lent itself well to the numerous community parks that are both pleasing to the eye and useful for the purposes of relaxation and recreation. These spaces have long been multipurpose in nature as places for sporting events, summer concerts, or simple picnics. Piqua's closeness to nature made the establishment of organizations like the Boy Scouts and the Girl Scouts a natural progression. Recreation for Piqua has also included quieter, more introspective spaces, such as libraries, where a book might be enjoyed in a peaceful surrounding. These are but some of the spaces that provide the citizens of Piqua with recreation and enjoyment.

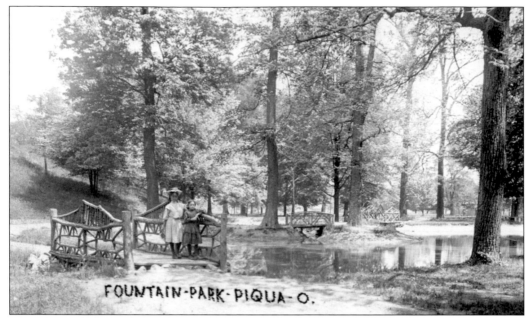

FOUNTAIN-PARK-PIQUA-O.

Fountain Park, located on the west side of the city at the end of Park Avenue, served as Piqua's largest and most widely used public park for decades. It started as the site of the original county fairgrounds during the mid-1870s before it became the location of a horse track from 1878 until 1887, when it transitioned into a park. In the late 1920s, it covered 20 acres and featured playground equipment.

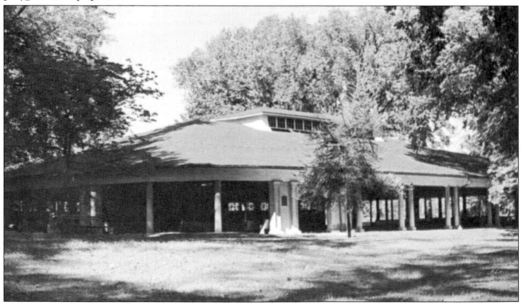

One of Fountain Park's most prominent features is Hance Pavilion, the auditorium used during the summer months for various Chautauqua programs as well as for shelter to picnickers. While the Chautauqua Festival's popularity faded in the 1930s, the pavilion continued to be the site of performances by groups such as the Piqua Band and Elks Glee Club. Today, Hance Pavilion is home to the Piqua Civic Band's summer concerts, as well as Music Warehouse, a summer musical theater program for area youth.

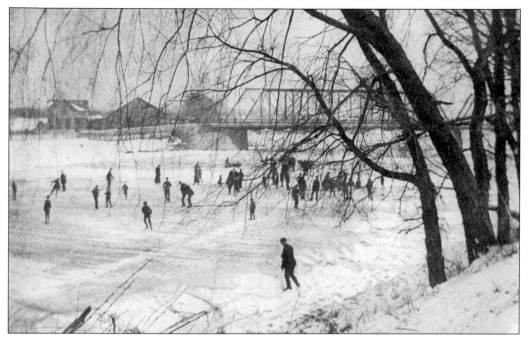

This charming winter scene from 1912 shows ice-skaters taking advantage of the frozen Miami River. The following year would bring the torrential rain and flooding that took multiple lives and destroyed much of Piqua, including the metal Shawnee Bridge on East Main Street, visible in the background. After the flood, the bridge was replaced with a sturdier concrete structure.

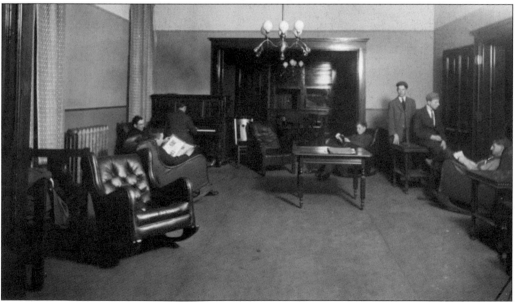

Concerned residents of Piqua laid the groundwork for the YMCA in the 1870s as a means of counterbalancing the perceived destructive influence of bars and saloons on the youth of Piqua. The YMCA opened its first reading room with furniture from the Women's Christian Temperance Union and books from the Greene Street Sunday School—in a former saloon. This photograph from the early 1900s shows the reading room in the YMCA's building on High Street. (Courtesy of the Miami County YMCA.)

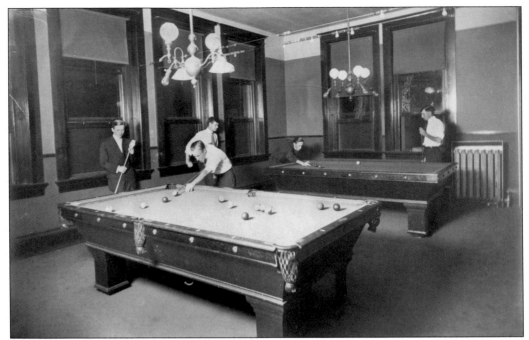

While the Piqua YMCA's reading room was a prominent locus of activity, acting as the site of music recitals, lectures, socials, and meals, it did not eclipse the draw of the billiards room, shown here around 1910. The High Street building also featured a lounge, gymnasium, handball court, and the city's first indoor pool, with dimensions of 20 feet by 23 feet. (Courtesy of the Miami County YMCA.)

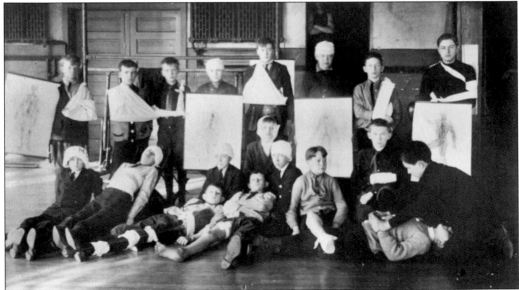

In addition to promoting leisure pastimes such as cycling, basketball, checkers, and chess, Piqua's YMCA established the first Boy Scout troop in 1907. In this 1911 photograph, the first scouts, numbering roughly 20, showcase the first aid skills they had acquired using bandages. Some of the boys also appear to be playing the role of drowning victims. (Courtesy of the Miami County YMCA.)

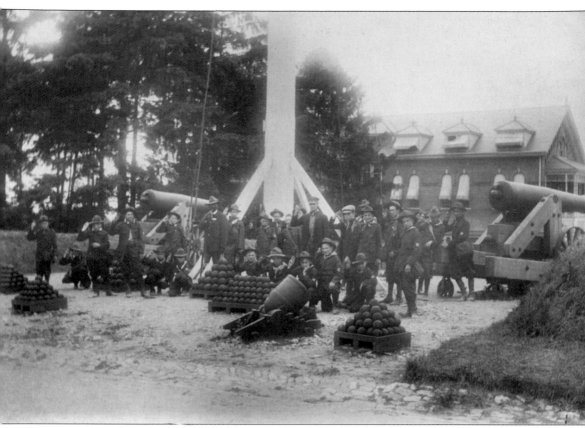

Piqua's first Boy Scout troop also took part in day and overnight trips intended to deepen and improve their understanding of civic duty and history. Offering a salute while surrounded by cannons and stacks of cannonballs, the boys are pictured here in 1911 during an excursion to a military installation in Dayton. The Boy Scouts would dissolve only a few years after forming but would return with greater urgency in early 1918, at the height of America's participation in World War I. This new troop stayed in operation and now exists as Boy Scout Troop 295. (Courtesy of the Miami County YMCA.)

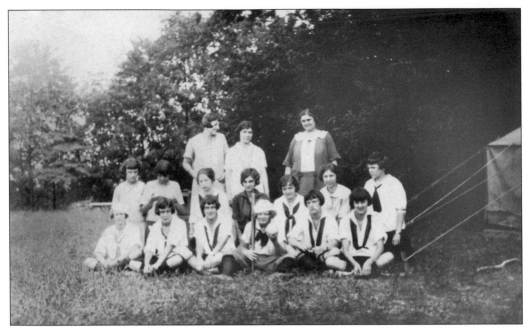

The YWCA funded trips for its members to Camp Rundle, such as this Leaders Club trip in 1924. The following year, Eleanor Jamieson, a teacher at Central High School, organized Piqua's first Girl Scout troop. The Girl Scouts aimed to train girls in the finer points of precision marching, semaphore, and Morse code. The 120 members met every week at Westminster Presbyterian Church until the troop disbanded in 1928. The Girl Scouts later returned in 1940. (Courtesy of the Miami County YMCA.)

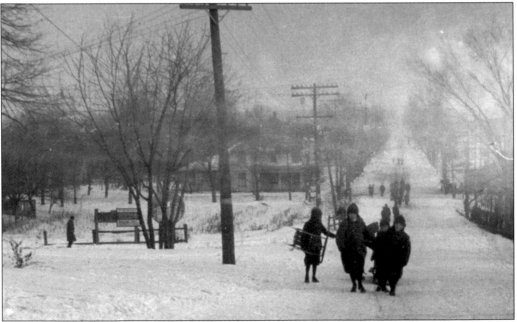

The future location of Mote Park included Hall's Hill, a prime spot for sledding and wintertime fun, as seen in this photograph from the 1920s. Mote Park opened in the late 1940s and became the location of the Mote Park Community Center in the early 1950s.

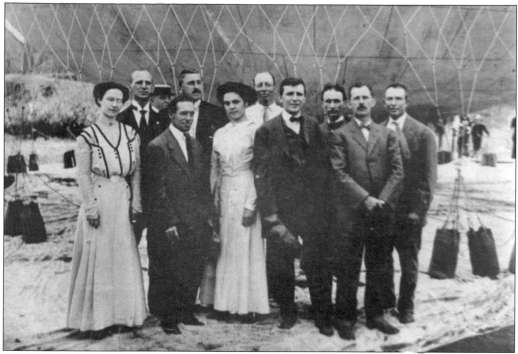

Piqua was the location of many critical events in the history of Ohio aviation, both before and after the advent of powered flight in the early 20th century. When these photographs of balloons were taken in Piqua in the early 1900s, such sights had become relatively commonplace. Famed balloonists Thaddeus Lowe and John Wise made a number of ascensions in southern Ohio during the years before and after the Civil War. The balloons in these images were most likely inflated with highly flammable hydrogen or coal gas. Hot-air balloons did not come into use until more than 50 years later.

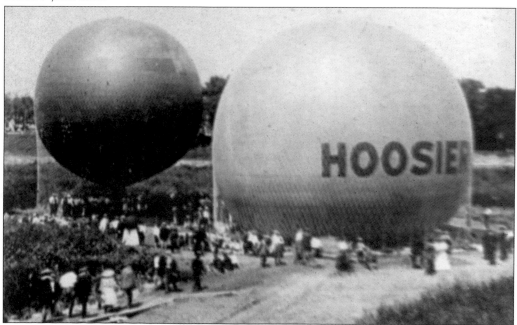

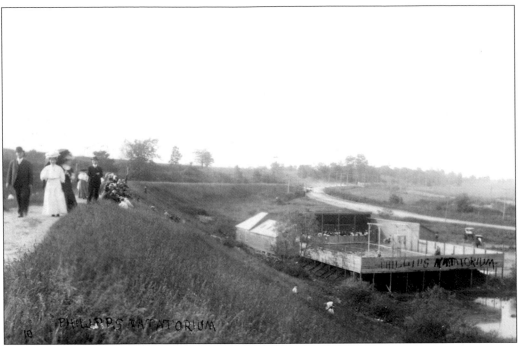

These two images provide views of Phillips Natatorium during its heyday in the early 1910s. One of the first outdoor pools enjoyed by Piquads, this aboveground, mud-bottomed outdoor pool opened for business in 1907 along the banks of the levee, near the future site of the municipal waterworks plant. Its closeness to the river led to the natatorium's destruction during the March 1913 flood. The structure was filled in with sand and became the location of the Swift Run Egg Farm, while the natatorium's proprietors went on to manage the Dayton Pool.

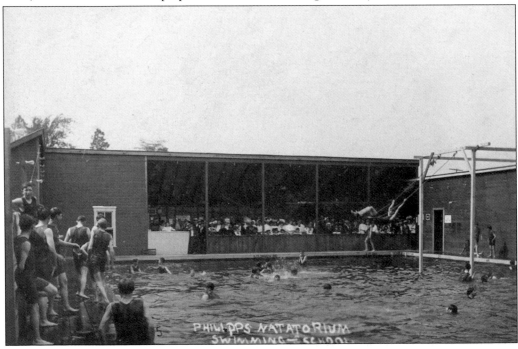

The destruction of Phillips Natatorium in 1913 created a void later filled by Lange's Natatorium. Located at the corner of Water and Spring Streets, Lange's pool (pictured) was an enticing refuge from the summer heat that attracted thousands of visitors during the 1920s. It was not uncommon for upwards of 1,500 people to descend upon Lange's during the weekends. Mixed swimming by both genders was forbidden. Lange's reigned supreme until unseated by a new outdoor pool, the Hollow. The Hollow started as a 48-square-foot pool dug by Walter "Arch" McKinney in 1930. Originally dubbed the Shimmy Hollow Amusement Park, this site east of Piqua had once been considered as a potential city dump. An artesian well pumping 200 gallons per minute supplied the water.

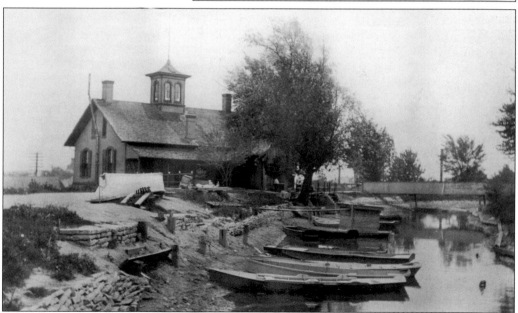

The waterworks at the end of North Street is visible in this image from the 1920s or 1930s. The city formally dedicated the facility in 1926 to provide the residents with clean water. Note the row of boats in the foreground. Piqua's location next to the Miami River, and the myriad of levees and creeks feeding the river, encouraged boating.

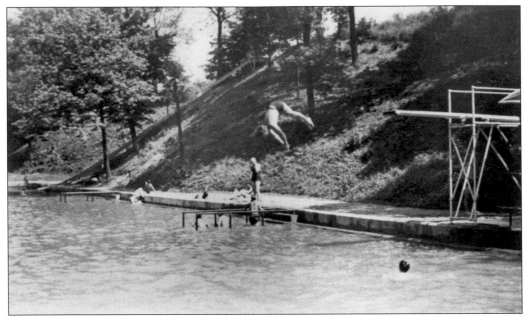

Leon F. Koester, a Piqua lumberman, took over the pool at the Shimmy Hollow Amusement Park shortly after its 1930 opening and shortened its name to the Hollow. Koester set about improving the site by concreting the pool's bottom and covering it with a four-inch layer of sand. Advertisements from the 1930s boasted the Hollow's cleanliness, with thorough chlorination, as well as its safety, provided by four or five lifeguards on duty at all times. With 30 acres of picnic grounds, a pair of diving boards, and an 80-foot-long toboggan slide, there were plenty of activities and amusements for those who traveled from Troy, Greenville, Urbana, Sidney, and Piqua. The pool retained its popularity for four decades, becoming the city's property in 1974. The Piqua Board of Health declared it to be in violation of several state health regulations in 1977. In 1988, the city filled in the Hollow, and today, picnic pavilions and trails dominate this park.

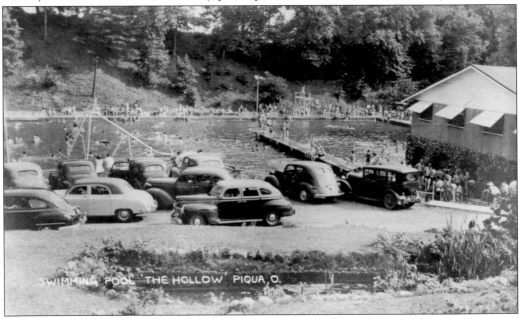

SWIMMING POOL "THE HOLLOW" PIQUA, O.

In the early 1900s, the 110 members of the Piqua Country Club constructed the area's first nine-hole golf course, located on 62 acres three miles northeast of the city. Members and their guests could take advantage of the screened porch, two tennis courts, ballroom, swimming pool, and dining facilities of the white Dutch Colonial–style clubhouse. In 1923, city planners moved forward with the construction of a municipal golf course, a more affordable option for Piqua's golfers. Area women came together to form the city's General Federation of Women's Clubs and to offer assistance to city planners in making golf available to the public at reasonable rates. As a result of their efforts, the nine-hole City Golf Course, pictured here, opened in 1925.

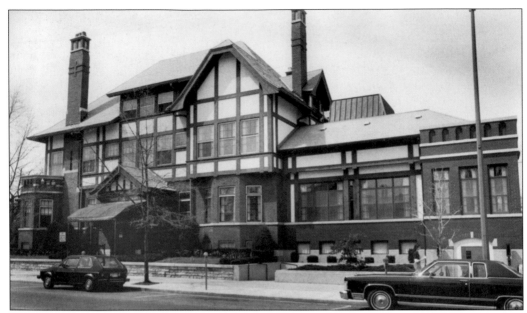

In the 1930s, Piqua claimed five libraries. Two of them, including the Flesh Public Library, were open to the public free of charge, while the other three charged fees or required a membership. In 1931, the former home of the Piqua Club, an association made up of a group of leading citizens, became the Flesh Public Library, shown here shortly after an addition around 1980.

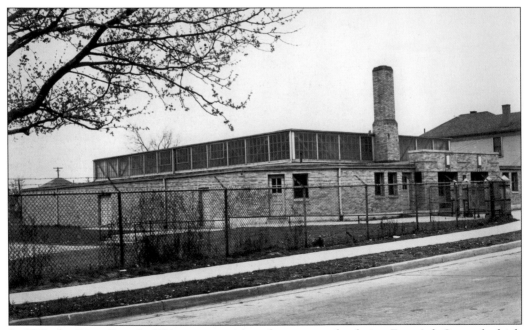

In 1921, the Piqua Board of Education purchased a six-acre plot facing East Ash Street for high school athletic events, particularly football games. The Rotary Club chipped in funds to purchase equipment and have the field graded. The facility took the name Roosevelt Field after Theodore Roosevelt. The Works Progress Administration constructed the Roosevelt Field House, shown here in 1939.

The years after World War II were ones of expansion for the Piqua YMCA. Programming expanded to accommodate a wider age range of schoolboys and a broader range of activities. Dances were held at the building in addition to existing programs like basketball and gymnastics. This 1950s photograph shows the YMCA gymnastics team refining their techniques. (Courtesy of the Miami County YMCA.)

The Favorite Hotel, while first and foremost providing temporary lodgings for visitors to Piqua, was also a place for recreation and relaxation for those not living out of a suitcase. This picture from the 1960s shows four groups of card players taking advantage of the elegant surroundings of the second-floor lobby to play a few hands of their preferred games.

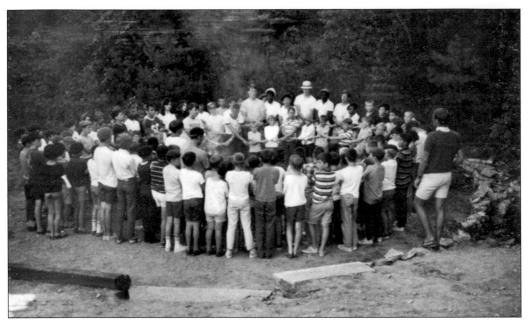

The YMCA's Camp Wakonda was a popular summer destination for many area youth. After years of moving to different sites under the name Camp Rundle, the YMCA's camping program settled on land sold to them by Lester Heaton in 1927. Camp Rundle was changed to Camp Wakonda, the Sioux term for "great spirit." In the above image from 1967, campers gather around the campfire, a nightly ritual that celebrated community. Below is a group of campers from 1965. In 1963, the procurement of a bus allowed for the transportation of day campers to Camp Wakonda. Local church groups, band groups, and the YWCA could also rent the camp for use. (Both, courtesy of the Miami County YMCA.)

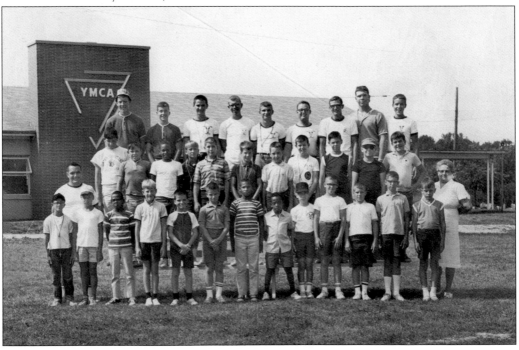

Eight

MUSEUMS AND HISTORIC SITES

A community must be aware of the significance of its past and willing to observe the defining events and personalities instrumental in its evolution and growth. The residents of Piqua have carried out this task with admirable and inspiring zeal. Reminders dot the city and its surroundings in the form of statues, plaques, and markers, each telling part of a larger story, a story of a community of humble origins, to inspire and motivate current residents. This pursuit must continue, however. Community members must continue to retrieve the stories of the past—especially those stories that have not yet been given a voice—in order to strengthen the ties that bind the community together.

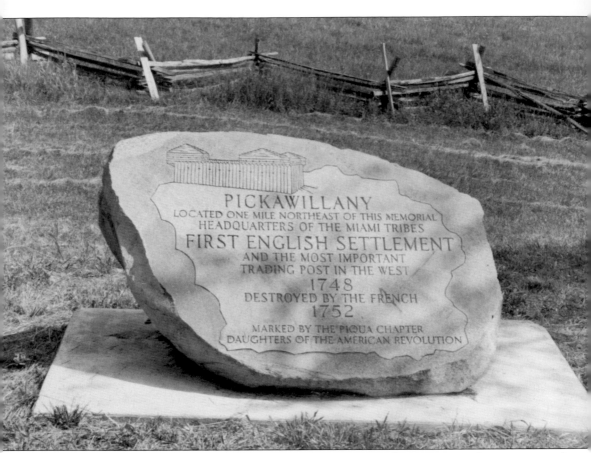

The attentive work of Piqua's Daughters of the American Revolution ensures that centuries of local history continue to be observed and commemorated. The DAR supplied the funds for this historical marker on the Johnston Farm and Indian Agency denoting the nearby location of Pickawillany, the first English community in the region. During the 1740s and 1750s, tensions between the English and French escalated over land possession and the right to trade with the Miami, eventually giving way to war. The French monopolized trade with the Miami, with the exception of one village, led by Chief Old Britain, who saw fit to trade with the English. To cement this relationship and drive a wedge in the area, English traders of the late 1740s opened a trading post named Pickawillany. It became the base of operations for nearly 50 traders and a thorn in the side of the French, one they decided to dislodge in an attack in the summer of 1752, an event which left Pickawillany a smoldering ruin and helped to propel the English and French closer to the French and Indian War.

This historical marker once identified the location of what was believed to be the last battle of the French and Indian War. Given that the sacking of Pickawillany was one of the preliminary events in the conflict, it would be appropriate that the war should come to an end at a nearby location, but there is a scarcity of evidence to prove the battle actually took place. The war pitted various Native American tribes against one another; an alliance of Cherokees, Delawares, and Shawnees fought with the English against the French and their Miami, Ottawa, and Wyandotte allies. The supposed final battle of the war, an English victory, occurred near Swift Run Creek in the summer of 1763. The marker from 1898, shown above, was moved from its original location to Johnston Farm, and 108 years after its dedication, the DAR added the disclaimer below. (Both, authors' collection.)

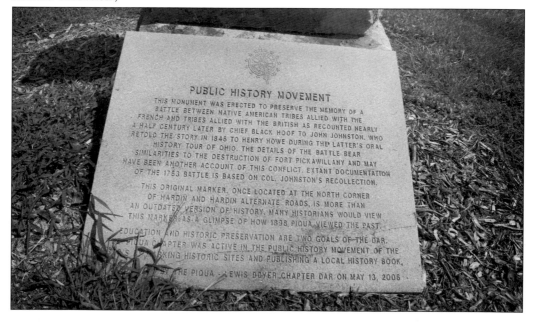

PUBLIC HISTORY MOVEMENT

THIS MONUMENT WAS ERECTED TO PRESERVE THE MEMORY OF A BATTLE BETWEEN NATIVE AMERICAN TRIBES ALLIED WITH THE FRENCH AND TRIBES ALLIED WITH THE BRITISH AS RECOUNTED NEARLY A HALF CENTURY LATER BY CHIEF BLACK HOOF TO JOHN JOHNSTON, WHO RETOLD THE STORY IN 1846 TO HENRY HOWE DURING THE LATTER'S ORAL HISTORY TOUR OF OHIO. THE DETAILS OF THE BATTLE BEAR SIMILARITIES TO THE DESTRUCTION OF FORT PICKAWILLANY AND MAY HAVE BEEN ANOTHER ACCOUNT OF THIS CONFLICT. EXTANT DOCUMENTATION OF THE 1763 BATTLE IS BASED ON COL. JOHNSTON'S RECOLLECTION.

THIS ORIGINAL MARKER, ONCE LOCATED AT THE NORTH CORNER OF HARDIN AND HARDIN ALTERNATE ROADS, IS MORE THAN AN OUTDATED VERSION OF HISTORY. MANY HISTORIANS WOULD VIEW THIS MARKER AS A GLIMPSE OF HOW 1898 PIQUA VIEWED THE PAST.

EDUCATION AND HISTORIC PRESERVATION ARE TWO GOALS OF THE DAR. PIQUA CHAPTER WAS ACTIVE IN THE PUBLIC HISTORY MOVEMENT OF THE ... MARKING HISTORIC SITES AND PUBLISHING A LOCAL HISTORY BOOK.

... THE PIQUA - LEWIS BOYER CHAPTER DAR ON MAY 13, 2006

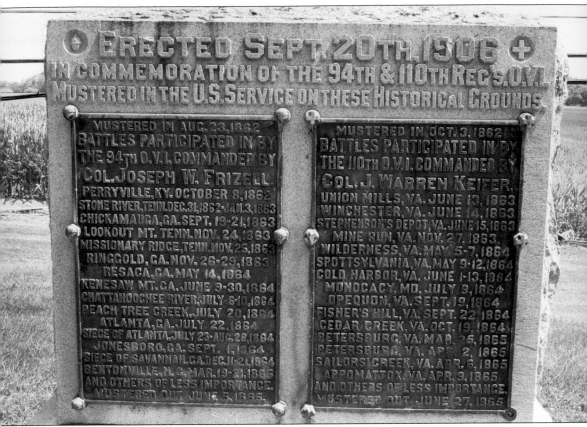

ERECTED SEPT. 20TH, 1906
IN COMMEMORATION OF THE 94TH & 110TH REG'S O.V.I.
MUSTERED IN THE U.S. SERVICE ON THESE HISTORICAL GROUNDS

MUSTERED IN AUG. 23, 1862
BATTLES PARTICIPATED IN BY
THE 94TH O.V.I. COMMANDED BY
COL. JOSEPH W. FRIZELL.
PERRYVILLE, KY. OCTOBER 8, 1862
STONE RIVER, TENN. DEC. 31, 1862-JAN. 3, 1863
CHICKAMAUGA, GA. SEPT. 19-21, 1863
LOOKOUT MT. TENN. NOV. 24, 1863
MISSIONARY RIDGE, TENN. NOV. 25, 1863
RINGGOLD, GA. NOV. 26-29, 1863
RESACA, GA. MAY 14, 1864
KENESAW MT. GA. JUNE 9-30, 1864
CHATTAHOOCHEE RIVER, JULY 8-10, 1864
PEACH TREE CREEK, JULY 20, 1864
ATLANTA, GA. JULY 22, 1864
SIEGE OF ATLANTA, JULY 23-AUG. 28, 1864
JONESBORO, GA. SEPT. 1, 1864
SIEGE OF SAVANNAH, GA. DEC. 11-21, 1864
BENTONVILLE, N. C. MAR. 19-21, 1865
AND OTHERS OF LESS IMPORTANCE.
MUSTERED OUT JUNE 5, 1865.

MUSTERED IN OCT. 3, 1862
BATTLES PARTICIPATED IN BY
THE 110TH O.V.I. COMMANDED BY
COL. J. WARREN KEIFER.
UNION MILLS, VA. JUNE 13, 1863
WINCHESTER, VA. JUNE 14, 1863
STEPHENSON'S DEPOT, VA. JUNE 15, 1863
MINE RUN, VA. NOV. 27, 1863
WILDERNESS, VA. MAY 5-7, 1864
SPOTTSYLVANIA, VA. MAY 9-12, 1864
COLD HARBOR, VA. JUNE 1-13, 1864
MONOCACY, MD. JULY 9, 1864
OPEQUON, VA. SEPT. 19, 1864
FISHER'S HILL, VA. SEPT. 22, 1864
CEDAR CREEK, VA. OCT. 19, 1864
PETERSBURG, VA. MAR. 25, 1865
PETERSBURG, VA. APR. 2, 1865
SAILORS CREEK, VA. APR. 6, 1865
APPOMATTOX, VA. APR. 9, 1865
AND OTHERS OF LESS IMPORTANCE.
MUSTERED OUT JUNE 27, 1865.

Another historical marker at Johnston Farm was erected to honor the memory of soldiers from the area who served in the 94th and 110th Regiments of the Ohio Volunteer Infantry (OVI) during the Civil War. In the early summer of 1862, Ohio governor David Tod commanded that the old Johnston Farm and Indian Agency serve as the site of a training camp for the 94th Regiment of the OVI. The 94th and 110th Regiments trained and drilled, often without the proper equipment, at what became known as Fort Piqua. These troops went on to see some of the war's fiercest fighting at the Battles of Brandy Station and the Wilderness. This marker makes no reference to area African Americans who volunteered for the Massachusetts 54th (later the 55th) Regiment, a unit consisting exclusively of black troops who fought for less pay than their white counterparts. John Bailey, Paul Crowder, and Jesse Luckyear are the three known black residents from Piqua who joined the regiment. Piqua would send between 400 and 500 men to fight in the war. (Authors' collection.)

In the late 1830s, several former slaves of John Randolph, who bequeathed them their freedom in his will, arrived in the Miami Valley from Roanoke, Virginia, following a contentious four-year legal battle with the late plantation owner's family, who wished to retain ownership of them. A provision of Randolph's will set aside $8,000 for the purchase of land in Ohio. After much difficulty in finding a location where they could settle in peace, the former slaves founded a number of settlements in southern Ohio. Those in Miami County were Hanktown, Marshall Town, and Rossville; of the three, only Rossville, near Piqua, remains standing. Shown here are the gateway of Jackson Cemetery and a historical marker provided by the Piqua DAR in 1980. Jackson Cemetery was listed in the National Register of Historic Places in 1982. (Both, authors' collection.)

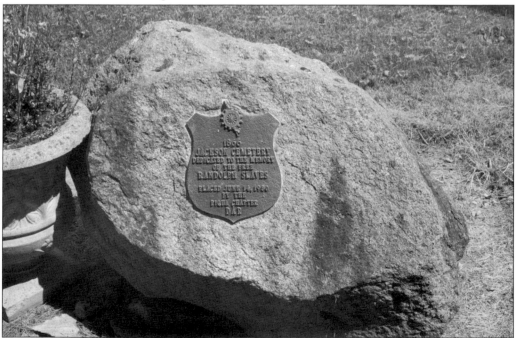

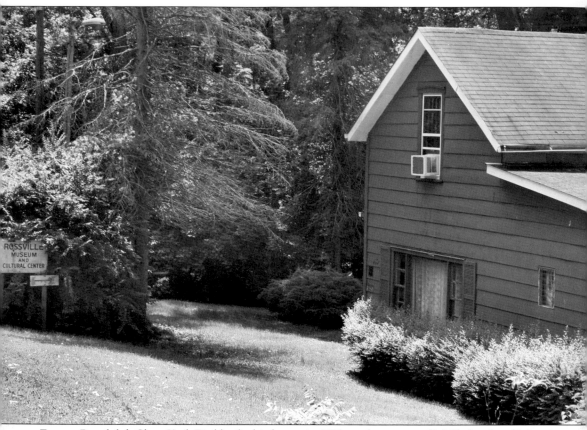

Former Randolph Slave York Rial built this house in 1873 on the corner of McFarland and Miami Streets. In 1907, Rial and fellow Rossville resident Joseph Morton laid the groundwork for a legal suit on behalf of the remaining former slaves and their relatives for money and property promised in John Randolph's will that was never made available. A decade of hearings followed without success. Rial died in the 1913 flood. Located near the Jackson Cemetery, the Rial house is the present location of the Rossville Museum and African American Cultural Center, which honors and preserves the memory of African Americans from Piqua, such as the Randolph Slaves and the Mills Brothers, with a number of exhibits regarding American and African history. The Rial house was listed in the National Register of Historic Places in 1984. (Authors' collection.)

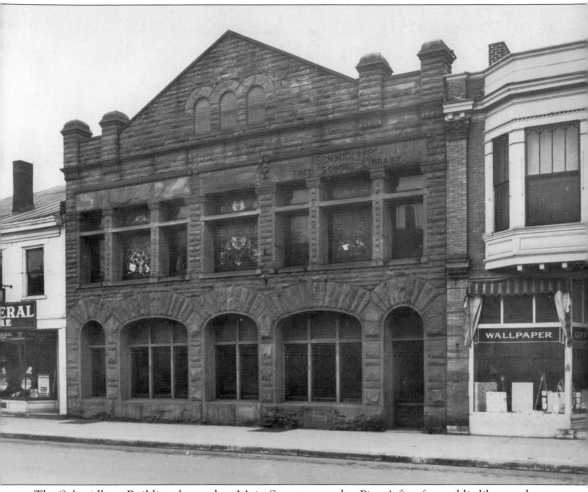

The Schmidlapp Building, located on Main Street, started as Piqua's first free public library when it opened in 1890, courtesy of Jacob G. Schmidlapp, who donated the building the previous year. Schmidlapp was born in Piqua in 1849 and went on to make a fortune as an international financier and banker operating out of Cincinnati. He pursued a number of philanthropic projects throughout his life, including attempts to improve housing for Cincinnati's poorer inhabitants. Cincinnati was not the only city to benefit from Schmidlapp's generosity. He saw to it that the building he donated, a former grocery store, was properly remodeled before reopening as the Schmidlapp Free School Library in the fall of 1890. It remained open for the next four decades, until the Flesh Library opened. It later became a museum devoted to Piqua's history.

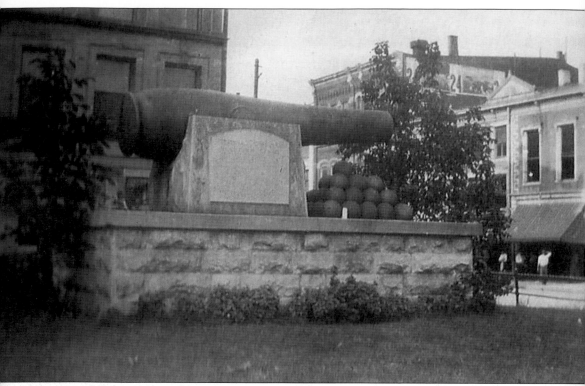

Stephen Clegg Rowan and his family immigrated to Piqua from Ireland when he was a child. In 1826, at the age of 18, Rowan joined the US Navy as a midshipman and spent the years 1830–1832 stationed in New York City. He saw action in a series of naval operations off California during the Mexican War in the mid-1840s. At the start of the Civil War, Rowan commanded a warship, the *Pawnee,* and is credited with firing the first naval gun in the conflict. He rose through the ranks with impressive speed, promoted to captain in 1861, commodore in 1865, rear admiral in 1866, and vice admiral in 1870. At the time of his death in 1890, Rowan enjoyed a reputation as a popular and respected officer. In 1909, Jacob G. Schmidlapp donated a memorial to honor Rowan on the northwest corner of the public square. The memorial consisted of a 20-ton naval cannon situated atop a stone block engraved with a record of Rowan's accomplishments. The cannon and its accompanying cannonballs were scrapped during World War II.

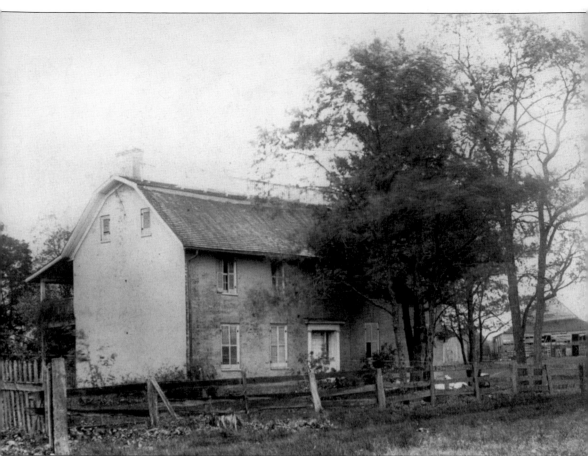

Piqua's most popular and recognized historic location, Johnston's Farm and Indian Agency, remained in the Johnston family for several years. Colonel Johnston passed on ownership of the farm to his son John Henry Dearborn so that he might raise his family there. Dearborn and his wife only stayed in the house for five years before moving to Piqua. Upon his death in 1863, the property's ownership shifted to Colonel Johnston's son William, who also opted not to live in the house. Robert Blackwood purchased the farm in 1871 and resided there. When this photograph was taken in the early 1900s, John W. Morris, a local newspaper publisher, owned the property, though he did not live there. Following Morris's death in 1906, his family used the farm as a rental property for several years. His three daughters later decided to sell the farm to the state of Ohio for historic preservation.

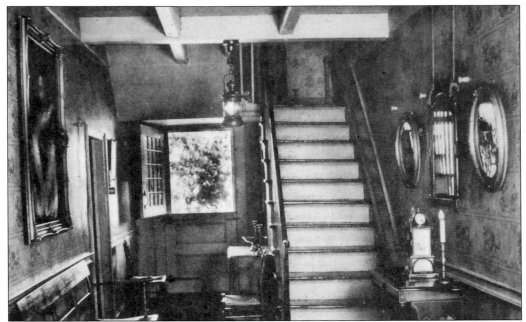

The above photograph shows the foyer of the Johnston house as it appeared in the 1900s, when it was still owned by the Morris family. The home's condition declined during its use as a rental property. In late July 1959, the Ohio House of Representatives earmarked an initial $10,000 for the Ohio Historical Society for the development of the Piqua Historical Area, with particular emphasis on transforming the Johnston Farm into a "State Memorial," or state historical park covering almost 369 acres. During the restoration process in the late 1960s, this staircase needed to be replaced; below, the farmhouse is encased in scaffolding from the project. (Both, courtesy of the Johnston Farm and Indian Agency.)

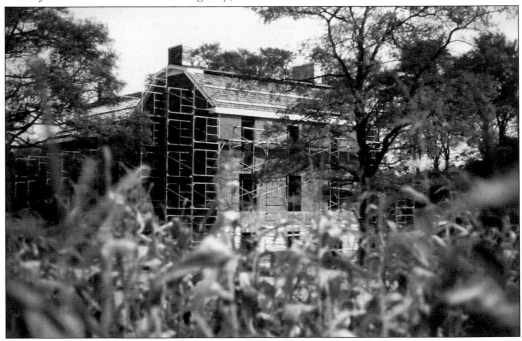

Part of the $1.4 million of state money that went into transforming the Johnston Farm included restoring a portion of the long-defunct Miami Canal so that visitors might experience what it would be like to travel down these critical waterways during the mid-1800s. Much of the canal had been closed in 1912, and it sustained substantial damage during the following year's flood. Surviving sections continued to be used for swimming and ice-skating, while others were reappropriated for canal use. The Ohio Department of Public Works donated part of the Miami Canal located on the Johnston Farm property to the Ohio Historical Society. In this photograph, one of the mules purchased to help pull the canal boat is offered a small snack. (Courtesy of the Johnston Farm and Indian Agency.)

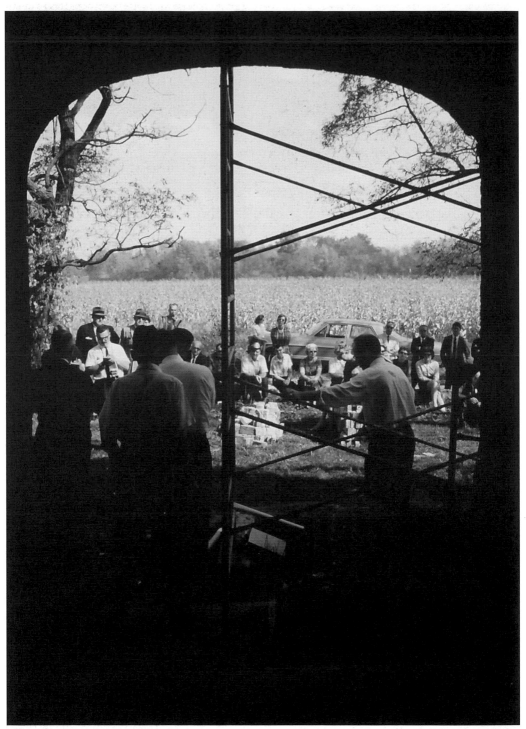

John Carpenter, a contractor from the Piqua area, led the restoration of the farmhouse beginning in 1968. A group of local historians and researchers made sure that the work retained the aesthetic of the period in which the house was built. Visitors frequently stopped by to observe the progress as the work continued over the years. (Courtesy of the Johnston Farm and Indian Agency.)

In September 1972, after four years of meticulous work, the Piqua Historical Area State Memorial was finally dedicated and opened to the public for tours. It was now possible to appreciate how thoroughly the house had been restored to its original appearance, with each room, including the bedroom shown below, outfitted with appropriate paint colors and furniture. Not long after the home was finished, restoration on the farm's nearby springhouse began. (Both, courtesy of the Johnston Farm and Indian Agency.)

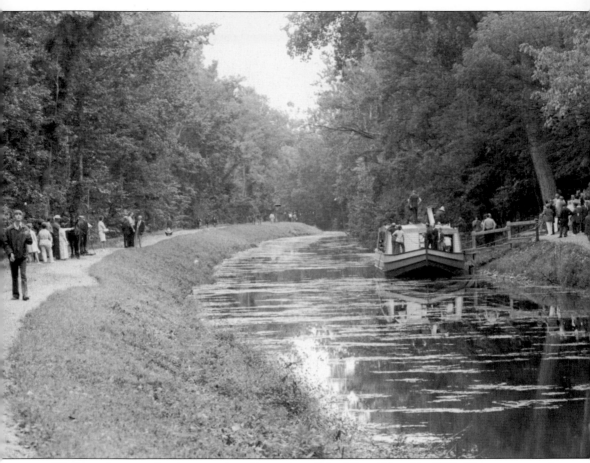

Workers also completed restoration of a section of the Miami Canal in 1972. The same year that the Johnston Farmhouse opened its doors to visitors, a replica canal boat—the distinctive blue-and-yellow *General Harrison*, named after Colonel Johnston's close friend and confidant—began to carry passengers along the canal. Mules used at Johnston Farm live in a restored barn located on the property, close to the farmhouse. The site has expanded to include an education center where students and visitors can acquire a greater understanding of the area's history, from its first Native American inhabitants to construction of the first settlements and canals. The education center has a variety of historic artifacts on display, including a number of pieces recently found at the Pickawillany site by students from Hocking College and the Ohio Historical Society.

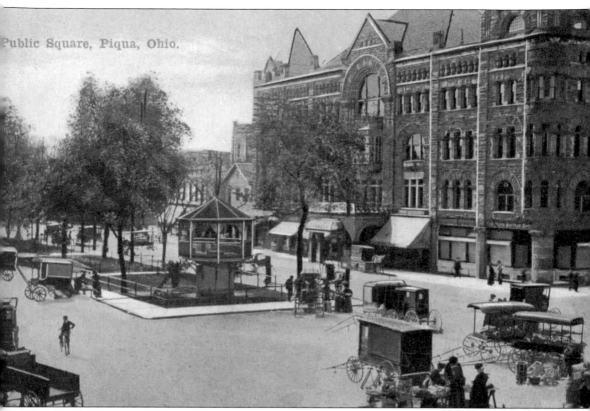

Public Square, Piqua, Ohio.

Another of Piqua's famous landmarks is the Fort Piqua Hotel, initially named the Plaza Hotel when it first opened. Though bustling in its heyday, as shown here, the Fort Piqua Hotel closed its doors in the latter half of the 20th century. It remained empty for decades and fell into disrepair. Efforts to restore the building to its former glory and to once again establish the structure as a beacon for the Piqua community proved successful early in the 21st century. Through fundraising efforts, city funds, grants, and private donations, the building became once again a locus of community activity.

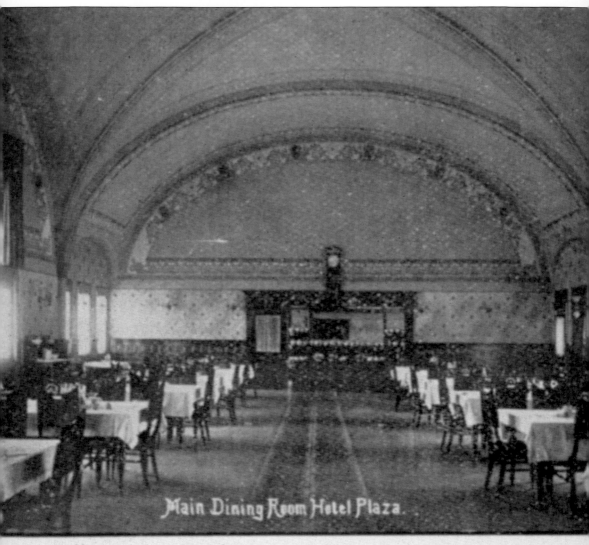

Main Dining Room Hotel Plaza.

"A GOOD COOK IS THE BEST PHYSICIAN."

Professional musicians wove soothing melodies for diners as they enjoyed meals in the hotel's main dining space on the fourth floor. In its halcyon days, the hotel's managers retained world-class chefs to prepare all manner of elaborate meals. Turkey was a particular favorite of customers. (Courtesy of Piqua Public Library Local History Department.)

The drastic rebuilding required to restore the main dining room is apparent above. The elegant space today is far removed from this state of disrepair. Below is the front exterior of the hotel after restoration. It is truly a multipurpose structure, with a public library, conference rooms, a reception hall, a restaurant, and a coffee shop (managed by Winans) all sharing the historic space. The Fort Piqua is a perfect encapsulation of Piqua's commitment to preserving its past, an emblem of the historic and cultural significance of the Piqua community.

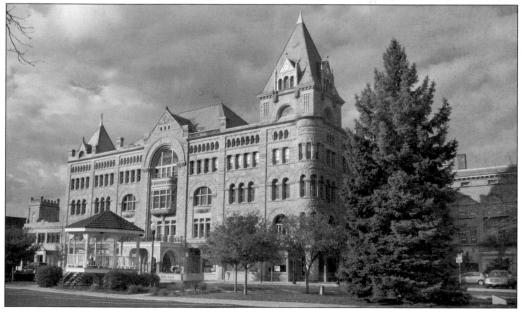

BIBLIOGRAPHY

Kaiser, A.J., ed. *The Piqua Ohio YMCA, 1877–1970.* Piqua: Hammer Graphics Inc., 1970.

Meek, Gary D. and Robin Heintz. "1913 Flood, Piqua, Ohio: A Driving/Walking Tour." Piqua: Piqua Public Library in association with Mainstreet Piqua Inc., 2013.

Oda, James C. *An Encyclopedia of Piqua, Ohio.* Evansville, IN: M.T. Publishing Company Inc., 2007.

Oda, James C. and Linda Grimes. *Piqua and Miami County: A Primer of Community History.* Piqua: Miami Printery Inc., 1991.

Piqua Chapter of the Daughters of the American Revolution. *Early History of Piqua and Some of the Pioneer Women.* 1899.

Rayner, John A., ed. *The First Century of Piqua, Ohio.* Piqua: The Magee Bros. Publishing Co., 1916.

INDEX

Discover Thousands of Local History Books
Featuring Millions of Vintage Images

Arcadia Publishing, the leading local history publisher in the United States, is committed to making history accessible and meaningful through publishing books that celebrate and preserve the heritage of America's people and places.

Find more books like this at
www.arcadiapublishing.com

Search for your hometown history, your old stomping grounds, and even your favorite sports team.